HISTORIC TALES OF
MICHIGAN
Up North

HISTORIC TALES OF
MICHIGAN
Up North

D. LAURENCE ROGERS

THE
History
PRESS

Published by The History Press
Charleston, SC
www.historypress.com

First published 2018

Manufactured in the United States

ISBN 9781467138666

Library of Congress Control Number: 2018932115

CONTENTS

CONTENTS

PREFACE

We hope to acquaint you with some of the amazing tales of Northern Michigan that have marked the past four centuries—pathfinders, padres and pioneers—as well as modern media-driven characters who have come to symbolize the region in our times such as…

…Ernest Hemingway, the Nobel Prize–winning author of *The Old Man and the Sea*, perhaps the most noted of visitors to Northern Michigan, his stories of the region still resonating with those who yearn to follow his footsteps;

…Charlton Heston, chisel-visaged actor, who portrayed biblical characters on Hollywood screens to great acclaim, his idyllic boyhood in Roscommon County shadowing him always and everywhere;

…And a stunning new face, rising actress Kateri Walker, proudly carrying her Chippewa heritage on a fearless crusade to rise above stereotypes and to re-identify her native people.

We will delve deeply into the past to search out the soul of the region of Northern Michigan, from the clash of cultures inherent in the expansion of Europeans of the seventeenth century into a land inhabited by pagan natives the minions of King Louis XIV converted to Chrisitanity, paving the way for later generations to steal their lands and animals and corrupt them with guns, liquor and foreign ways.

The greatest novelists of all time could scarcely imagine tales like those that shaped Northern Michigan:

…a misguided quest for a route to the Orient that went awry, unwittingly leading to a paradise of wealth, furs, trees, metals, opulently fertile lands;

…a seemingly barren place that miraculously sprouted copper and iron to undergird the Industrial Revolution and gave rise to teeming cities;

…surging waters of unimagined magnificence, that, when slashed by canals and locks, opened up a world that surpassed anything ever dreamt by avaricious Europeans.

A dozen Sancho Panzas dreaming their impossible dreams march through these pages, along with the Walter Mittys, the Mister Smiths, the aged prospectors of the gold rush—all hoping to find their Shangri La in Northern Michigan, many succeeding and living the American dream in the wooded game-rich place they crave. Others settle for a vicarious life of occasional visits to Nirvana, the iconic place we call Northern Michigan.

We welcome you to that world.

INTRODUCTION

Etienne had known lithe young women in his village of Champigny in France, who, with enough wine and gentle talk, would cast aside the admonitions of the local pere and the nuns and recklessly give themselves to the strong and verile young Gallic men. The plaintive wails of these wanton women seeking forgiveness echoed from the confessional at St. Eustache for weeks, while the men smiled and winked, pouting the familiar moue in mock sympathy. At age sixteen, Etienne was determined to spurn that pleasurable life he had witnessed, to dedicate himself to God and his beloved France by becoming a disciple of Samuel de Champlain, who was opening New France, Canada, and its lush lands, including Northern Michigan.

The aristocratic explorer Champlain and Etienne Brule, the son of a simple farmer of Champigny, risen from generations of serfdom, were among legions in the thrall of Louis XIV. The Sun King's regal radiance shone throughout the world—his magnificent manly figure draped with opulent robes of white silk dripping with gold, much as the French couturiers imagined the princes of the Orient might look.

There was a passage to the Orient, the French fervently believed, with riches beyond measure their slavering goal. Of course, it was a futile dream that vanished when they found themselves, after heroic ocean voyages, in the unforgiving wilds of North America. In addition to the natives, Louis's minions were opposed by the agents of the constitutional monarchy of Queen Elizabeth and by the unforgiving land and weather. The illiterate but fearless Brule, now eighteen, inveighed his lord, Champlain, to send him among

the Onantchataron, whose village was near the rude settlement of Quebec. He was to learn their language and be the chief translator; his mission was to entice from the natives bales of animal furs for shipment to France, fattening purses from Versailles to Normandy and helping pay for endless wars against the English.

The New France headquarters that was being fashioned by Champlain's men was notable for the lack of women, who were hesitant to leave the home country. Most of the men haughtily spurned the advances of the lusty bronze natives, preferring celibacy to profligacy. The English therefore had ten times more New World settlers, 250,000 to 25,000. Sexual restraint was not to be the style

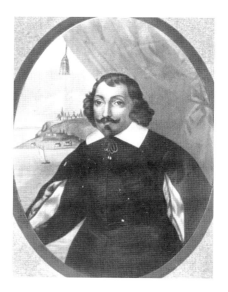

Champlain, who founded the first permanent European settlement north of Florida, Port Royal, Acadia. *Courtesy of the Library of Congress.*

of the lusty Brule, whose education lacked the religious stringencies of the black-robed fathers. He soon yielded to the siren call of dusky temptresses proffering forbidden native wantonness.

The Jesuit Relations, reports sent periodically from New France to Paris, did not include reports of the licentious habits of the Indians as encountered by Brule in the villages he visited. His reports filtered into literature only sparingly but no doubt would have been startling to prudish European standards of decency. Bronze maidens would strip off their deerskin shifts and madly dance naked in front of adoring assemblages of naked males. Couples paired up as desires dictated, often switching partners in what today would be called a mass orgy.

One rogue priest's recollections opens a rare window into the Indians' sexual proclivities that were so anathema to the long-faced black robes. Father Gabriel Sagard, who described himself as "an unworthy Recollect" in *Long Journey to the Country of the Hurons*, of 1632, no doubt beating his breast piously, recounted: "[T]he boys are at liberty to give themselves over to this wickedness as soon as they can, and the young girls prostitute themselves as soon as they are capable of doing so. Parents are often procurers of their own daughters." Trial marriages were common, Abbe Sagard wrote,

and divorce was only a matter of one partner renouncing the other. "After nightfall, the young women and girls run about from one lodge to another, as do the young men for their part on the same quest…leaving all to the wishes of the women." The missionaries "maintained their celibacy in the face of determined Indian offers," according to Sagard, even though the men often petitioned the priests to sin on behalf of the women. Only a lone Jesuit was rumored to succumbed to lust and, in a supreme act of contrition, jumped off a cliff to end his losing battle with temptation.

Brule used his intimate familiarity with the Indians to good advantage, becoming as "the King of the Coureurs de Bois." He traveled and lived with the tribes, opening vast territories for fur trading, discovering the Great Lakes and exploring Northern Michigan. He returned to France twice, 1623–24 and 1626–28, "covered in gold." He married, fathered several children and had homes in Champigny and Paris. After returning to New France, Brule's end came after a monumental mistake: Captured by English privateers, he threw in with them and guided them to Quebec, his treason allowing Champlain to be captured. Even as the French were planning to arrest and try him, the Hurons killed him in 1633. Some reports were that he was tortured, quartered and eaten by his former friends and sexual compatriots.

Thus was the stage set for an epic clash of cultures that shaped our world of today.

LURES FROM FURS TO POLITICS ENCHANT ALL WHO VISIT NORTHERN MICHIGAN

Northern Michigan: What hath God wrought in nearly four centuries? Some say a paradise vacationland with historical significance everywhere.

Long lines of black-robed missionaries, fearless natives braving the wilderness and pioneers in ships on churning waters or afoot in snowdrifts seeking fortunes and solace in a new land, these are some of the images evoked from this magical settlement land.

How did it all happen in a fraction of the eons it took for Europe to evolve from cave-dwelling barbarism to sophisticated civilization?

Our goal is to attempt analysis and exposition of this almost miraculous process.

About a century and a half after Christopher Columbus sailed from Spain to the New World, the most powerful empire in Europe—France—seeking a water route to the Pacific, the fabled Northwest Passage, what Kenneth Roberts called "that panacea for all the afflictions of a humdrum world," sent explorers to the wilderness that became Canada, including the area that became Northern Michigan. Roberts elaborated more expansively in his classic 1937 novel: "The Northwest Passage, in the imagination of all free people, is shortcut to fame, fortune and romance, a hidden route to Golconda and the mystic East."

The setting and the drama were among the epic in world history. The rocky landscape of forests sculpted and surrounded by the world's most massive inland seas were undiscovered but coveted by civilized and

literate peoples who had evolved into polite society after thousands of years as barbarians. Greedy, warlike European adventurers and black-robed mandarins holding aloft the cross of Jesus were desperate to please a powdered, cosseted monarch by converting hordes of half-naked cannabalistic natives to their God and to their uses for trade and profit. In some ways, they were more brutish than those they called savages, the innocent objects of their selfish intentions. It was a lush land more fully populated by millions of animals whose skins were currency to rapacious merchants overseas. Both the humans and the animals who met and interacted there were never to be the same.

Exploration soon led to two main focal points involving the natives: religious conversion and fur trading.

It was 1634 when Jean Nicolet, Sieur de Belleborne, traveling by canoe through the Straits of Mackinac, became the first European to tell of the magnificence of the Great Lakes and the tip of the mitten-shaped area that evolved into Michigan. The region was identified in an Indian language as "land of the great water." Nicolet, son of a king's messenger from Cherbourg, was part of Samuel de Champlain's cadre of young Frenchmen, along with Etienne Brule, assigned to live among the Indians and open fur trading routes. The livres garnered by the furs were needed by the ancien régime to finance its expensive European wars.

Even today, entering vast Northern Michigan, covered with evergreen and decidious forests slashed by asphalt highways and speckled with lonely homes, one's mind projects stark, dreamlike images of the past:

…of black-robed missionaries down from Quebec and Montreal to convert reluctant natives to the unfamiliar incense-smoked, holy water–sprinkled rituals of Catholicism;

…of hardy French voyageurs fueled by pemmican and brandy paddling canoes and long boats on treacherous waters to cajole Indians with trinkets and blankets, trade furs and survive brutal winters—a centuries-long struggle of man against the elements.

In the end, it was the voyageur, the equivalent of today's lunchpail-carrying industrial worker, who made possible the fur trade and the opening of Northern Michigan and other midwestern territories to civilization. Often living in Quebec, the voyageur signed on to paddle thousands of miles into the hinterlands of Michigan, Wisconsin, Illinois and beyond with trade goods for the tribes. Their double-wide trucks of the day were thirty-five-foot-long birchbark freight canoes. Those voyageurs who stayed the winter, the "hivernants," received double wages

but reaped little profit for acquiring furs from the Indians and cleaning and baling them. Then the bales were transported, often in flotillas of up to 150 canoes, to the spring rendezvous at Mackinac Island and then to warehouses in Quebec or New York for shipment to Europe and markets as far away as China.

"We may safely conclude that man existed in the territory now known as Northern Michigan ten thousand years ago," commented Perry Francis Powers (1857–1945) in his monumental 1912 *History of Northern Michigan*. In 1911, an earlier sage, Alvah L. Sawyer (1854–1925), wrote: "[I]n considering the variety and abundance of its natural resources and the part played thereby in the world of commerce, this little fraction of the universe leaps at once into prominence."

That prominence is evidenced by the fact that some of the major political policies have sprung from periodic conferences at the Grand Hotel on Mackinac Island. Also, the Moral Re-Armament movement was situated on the island for several years during the 1940s and 1950s, made moralistic movies in a complex at Mission Point and sought to instill peace among world leaders.

Beginning four hundred years ago, black-robed Jesuit and Recollect Catholic priests, as well as Lutheran and other Protestant missionaries, stalked vast breadth of the area that became known as Northern Michigan. They preached salvation from eternal damnation but unwittingly hurried the demise of many of their charges.

About half the Huron tribe were said to have died from diseases during the first two decades after European arrival. The Hurons, also known as Wendat, were especially susceptible because entire families lived communally in huge bark-covered longhouses, about 130 feet in length and 30 feet wide. Inside the longhouses were wide platforms at various levels, similar to huge bunk beds, where members of familial groups could gather and sleep. For protection, the longhouses were surrounded by a palisades of long poles that extended above the height of the dwellings.

The black robes wielded their influence among the aborigines by accepting the Indian way of life and their languages. Their secret to gaining acceptance was stated by a Jesuit, Jean de Brebeuf, in instructions for members of his order who were to follow: "You must have sincere affection for the savages—looking upon them as ransomed by the blood of the Son of God, and as our Brethren with whom we are to pass the rest of our lives."

The Jesuits lived among the natives, connecting through mystical practices, European religion relating to paganism. They explored huge territories,

HISTORIC TALES OF MICHIGAN UP NORTH

peacemaking, ministering and founding missions to perpetuate their work. Some missions became important cities: Alpena, Cadillac, Cheboygan, St. Ignace, Traverse City, Mackinaw City.

There is no French saint named Ignace. The town of 2,500 persons today was named for the Spanish founder of the Jesuit order, St. Ignatius of Loyola. It is the second-oldest city in Michigan after Sault Ste. Marie.

A perplexing question arises: What eerie, supernatural power did the Jesuits possess that they could enter a strange land of natives speaking unfamiliar tongues, bridge the huge cultural divide and somehow mesmerize them into embracing a completely foreign god? Add those complexities to the fact that the Jesuits brought disease and their compatriots, French soldiers and explorers, enticed them into use of alcohol that was poisonous to natives. The missionaries learned the native languages and were able to communicate religious concepts, sometimes through fear and also by the device of answering the mysteries of life, illness, death, the weather and so forth. They offered prayer as a panacea for health, for instance. But the Jesuits were blamed for outbreaks of disease or other calamities that beset the Indians. The new diseases continued to take their toll with periodic epidemics: smallpox, 1631, 1633 and 1639; unknown epidemic, 1646; influenza, 1647; smallpox, 1649; diphtheria, 1659; smallpox, 1670; influenza, 1675; smallpox, 1677 and 1679; smallpox and measles, 1687; and smallpox again, 1691, 1729, 1733, 1755 and 1758.

Jesuit Father Jacques Marquette (called Pere Marquette), whose statue looms over the Straits of Mackinac on Mackinac Island, personified the intrepid priests from France who were first in the wilderness. Their work set the pattern for settled towns with streets and homes, churches and schools—stable, cooperative, productive populations.

But all was not sweetness and light in the clash of civilizations, the conflict of opposite views of sex and society pitting the sterile mores of the celibate black-robed missionaries against the earthy, sexually uninhibited habits of the indigenous peoples. European habits were no doubt as strange to the aborigines. The Jesuits claimed to have converted some sixteen thousand Indians from 1632 to 1672. Protestants came later, but they were nonetheless important in the taming of Northern Michigan and its populace. Notable is Reverend William Ferry, a Presbyterian minister, who in 1823 established the Protestant mission and school at Mission Point on Mackinac Island.

There were a few intrepid women who braved the wilderness, too: Lady Antoinette Von Hoeffern, widow of an Austrian aristocrat and sister of Bishop Frederic Baraga, who aspired to form an order of nuns, built

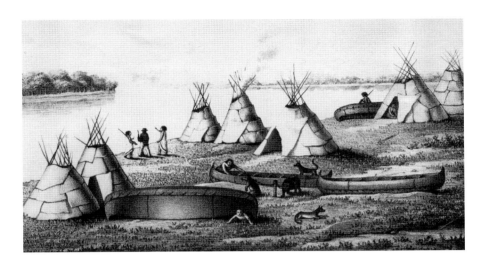

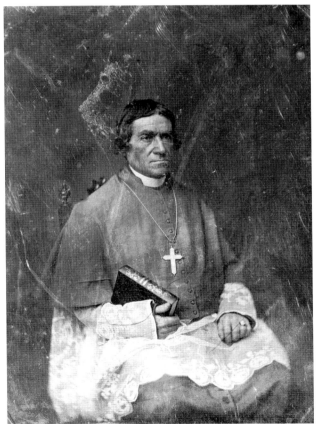

Above: Indians with teepees and canoes. *Michigan State University*.

Left: A Slovenian, Venerable Friderik Baraga (1797–1868), called the "Snowshoe Priest," ranged across Northern Michigan and the Upper Peninsula converting thousands of natives to the Catholic faith. He was the first bishop of the Diocese of Marquette, with headquarters at Sault Ste. Marie, and was a law graduate of the University of Vienna. He compiled a dictionary of the Otchipwe (Chippewa) language. *Courtesy of the Library of Congress*.

missions at Little Traverse and established an industrial school for Indian girls at Mackinac. She gave her fortune to the Indian missions and died of smallpox—contracted from victims here—in Europe in 1839. Of Odawa heritage, Madame Magdelaine LaFramboise and her elder sisters, Therese Schindler and Catherine Cadotte, became wealthy rivals to their male counterparts in the fur trade.

Called the "Snowshoe Priest," Bishop Baraga was a scholar, compiling a Chippewa grammar and the first Chippewa dictionary. Shortly after his elevation to the post of bishop, he issued circulars to his people in Chippewa and English. His jurisdiction extended to the entire Northern Peninsula as well as a large part of the Lower Peninsula. Soon, the discovery of iron and copper drew larger numbers of Catholics and others to his bishopric. They brought semi-barbarous legal codes and practices—"might makes right." Martin Heydenburk, Protestant teacher at the mission school at Mackinac, recalled "higher caste" men enforcing contracts with laborers through the whipping post. "But this soon faded away before the remonstrances of missionaries, and the better influences they brought to bear upon legal practice and common justice."

European immigrants to North America and the natives shared "very mixed experiences that ranged from war to negotiation," Michigan State University scholars observed. Tales of this star-crossed marriage of multifarious people and cultures—and associated events created by their stark diversity—will be the focus of this book.

HOW THE GRAND TRAVERSE INDIANS DISCOVERED THE WHITE MAN, NOT THE OTHER WAY AROUND

Historical reality often is nothing like that which becomes common belief as the years progress. There are several pertinent examples in Northern Michigan.

The Chippewa Indians of Grand Manitoulin Island, in what is now Grand Traverse County, became aware of the arrival of "the strange people from the region of the sun," the French, who had arrived in Quebec in 1608. In frail birch bark canoes, they traveled hundreds of miles north and "discovered" the white settlements on the St. Lawrence River. So, no, the white man didn't discover the Indians here as commonly believed. It was the other way around.

After receiving firearms from the accommodating French in return for furs, the Chippewa returned and used the guns to good effect in routing invading Prairie Indians (probably the Sioux) from the west. The Prairies were pursued to Sleeping Bear Point, and a decisive battle was fought on a point between Lake Michigan and Marquette Lake. Only a few of the Prairies were said to have escaped by swimming the river.

Thus began the fur trade: furs for guns, a process that soon spread to clothing and other items and allowed the Grand Manitoulin Indians to emulate white lifestyles. This soon led to a split between the "haves" and the "have nots" (those who did not engage in trade with the French).

In time, the trading Indians gained a decided superiority over those Indians who stayed at home and took no part in the fur trade, according to early histories. As the legend goes, the fur-trading Indians then adopted

the name Ottawa, confusing historians for all time. This group relocated on Mackinac Island and the mainland to the south but eventually reconciled with the Chippewa. These tribes have continued to dwell together in the Grand Traverse region.

The Chippewa (also called Ojibwe and Ojibwas), predecessors and progenitors of the Ottawas and Pottawatomies, migrated here due to an onset of colder weather (the start of the Little Ice Age) in the 1400s from their original homes near Hudson Bay. Upon their arrival, they drove out the Hurons, Sauks, Sioux and other tribes.

The question of whether Father Jacques (Pere) Marquette called it "Le Grande Traverse" in the late 1600s or whether the history begins in 1839 with the arrival of Protestant missionaries is one that should not be perplexing. In the first place, Marquette traveled extensively, mapped the regions he visited and learned six local Indian languages.

Father Marquette founded a mission at Mackinac Island/Sault Ste. Marie in 1668 and at St. Ignace in 1671, two years before he began his journey west with Louis Joliet that resulted in discovery of the Mississippi River. The main agricultural settlements of Michilimackinac were twenty miles north and about eight miles east of Little Traverse Bay. These were farms, gardens and villages held in common under Jesuit control beginning in 1612.

So, the Indians of the Grand Traverse–Leelanau area would have been within Pere Marquette's area of missionary influence long before the advent of Alexander Henry, the first English fur trader, who mentioned the name Grand Traverse as the place where he met a large party of Indians in 1763.

Was it Pere Marquette in the late 1600s, the English fur trader in 1763 or the Protestant missionaries in 1839 who attached the name Grand Traverse to the region? That is a matter that shall remain debatable, though the earlier French origin of the name "Le Grande Traverse" would appear to prevail, lending credence to the claim of supporters of the Pere Marquette theory.

We have mainly failed to recognize the importance of the town called Mackinaw City at the northeast corner of Emmet County to the ancien régime. This was Michilimackinac—old Mackinac (Mackinaw City)—one of three locations to which that name was attached. Another was Ancient Fort Mackinac at the bay at St. Ignace, five miles northwest of Mackinac Island (St. Martin's Bay), in the present St. Ignace Township. And third was the present village of Mackinac Island, located on the island.

Under the organization of New France, Michilimackinac included all the lands east to Quebec, south to the Ohio River, west to Minnesota and the huge drainage basin of Lakes Superior and Huron. It was an empire unto itself until the settlement of Detroit began in 1670. That was when French priests destroyed with axes a stone Indian idol there, and French settlers began trickling into the area known as Detroit (translation: the strait).

3

LIQUOR FOR FURS

WHY DETROIT REPLACED MICHILIMACKINAC AS CENTER OF NEW FRANCE

Was the use of "firewater" in trading for furs with the Indians the key reason Detroit superseded Michilimackinac as the center of power in New France? Too little historical attention has been paid to that question. French administrator Antoine de la Lamothe-Cadillac first traveled to the city in Cadillac's Convoy, a voyage of one hundred French soldiers in seventy-five canoes to Detroit in the summer of 1701. Those soldiers became the base population of the new city in what became the state of Michigan.

Lamothe-Cadillac had been commandant at Mackinac from 1694 to 1698 and was allegedly seeking a more strategically located central headquarters. The canoes and bateaux were loaded in Montreal for the two-month voyage down the Ottawa River, through Georgian Bay, Lake Huron and Lake St. Clair to Detroit. That route had thirty portages but avoided encountering the warlike Iroquois as expected on the Niagara Falls route. The convoys continued twice a year on that same route, bringing supplies and people.

In 1896, C.M. Burton wrote of Lamothe-Cadillac:

> *With the foresight of a skillful diplomat he reasoned that the location of a permanent colony on the Detroit River would tend to keep the English from trading among the upper or French Indians and, moreover, if the post once established was properly managed, the commandant could draw around in all the Indians of the west, and their numbers, added to the strength of a French garrison, would compel a peace with the warlike Iroquois.*

Antoine Laumet de la Mothe, Sieur de Cadillac, founder of Detroit. *Public domain.*

So, with the wave of one French seigneur's plumed hat, the regime's center of power shifted from the Straits of Mackinac some 250 miles south to Detroit, another watery strait.

But some theorists contend that the Roman Catholic Church's ban on selling liquor to the natives, proclaimed in 1643, prompted the ever-calculating Lamothe-Cadillac to shift his base of operations some 250 miles farther away from Quebec, where church authorities held sway.

Anna McCracken, of Loyola University—perhaps more realistically—argued this as the underlying cause of the move: "With Lamothe-Cadillac the chief conflict came when he championed the cause of some infamous coureurs-de-bois and French traders who bought fur pelts from the natives for brandy, 'eau-de-vie.'" The Jesuits said that the liquor had a demoralizing influence on their flock. Lamothe-Cadillac became impatient with the limitations of Michilimackinac after his conflicts with the Jesuits—backed by the powerful bishop of Paris—over using liquor in the fur trade with the Indians resulted in King Louis XIV revoking his trading licenses.

In 1704, Lamothe-Cadillac was removed from command at Detroit and sent to Quebec, where he was arrested on charges of tyranny and profiteering. (There was an extensive trade in brandy with the Indians at

Antoine Laumet de la Mothe Sieur de Cadillac, founder of Detroit, and his wife, Marie-Therese, land with his convoy after trip from Michilimackinac. *Public domain.*

Left: Indian guide in a canoe at the rapids of the St. Mary's River before the Soo Locks were built in 1855. *Courtesy of the Library of Congress.*

Right: Indian guides in their boats in Sault Ste. Marie. *Courtesy of the Library of Congress.*

Detroit.) Pardoned by the king, Lamothe-Cadillac returned to Detroit five years later, and in 1710, he was sent to Louisiana as governor.

This shift may have had massive consequences on modern developments like the auto industry. What would Mackinac be like today had Cadillac stayed there and used his influence to build a metropolis with massive industries?

Today, Northern Michigan conjures up almost magical mental images, of the smell of balsam, the crackle of wood fires and smoke wafting airborne, of silent winter days with streams eating slowly through the icy covering, of lodges hidden in dense forests on streams teeming with trout and grayling, of snowbound camps with dozens of deer strung on sagging poles by proud hunters.

Northern Michigan's largely uncollected history is replete with adventurous tales: of diminutive trapper Michael Daly running from the straits to Saginaw, 250 miles along the Lake Huron shoreline, beating the Indians and their dog train carrying the mail;

…of Father Nouvel, coasting Lake Huron with Indian guides in 1675, remarking on scrub trees that in two centuries grew to towering forests of pine and hardwood;

…of the heroic explorations of Douglass Houghton, state surveyor and geologist, tramping afoot mapping and evaluating the state's copious natural resources;

…of Grayling's Chief David Shoppenagon, building an AuSable refuge, Wa Wa Sum, still operated as a rustic camp by Michigan State University;

…of James Oliver Curwood, internationally known author of outdoor stories, and his rustic cabin on the same stream;

…and of the intrepid David Ward, trekking five hundred miles to an Otsego pine and hardwood stand, racing Soo Canal agents hundreds of miles south to the Ionia land office and recording his sixteen-thousand-acre claim, the start of a tremendous lumbering fortune.

These once-in-a-millennium human sparks started a blaze in the minds of Americans that will never cease to burn, one that rekindles with the recollections that spring alive whenever Northern Michigan is mentioned.

INTREPID FUR TRADER MADAME LAFRAMBOISE STYMIED TYCOON JOHN JACOB ASTOR

S he was a man's equal—perhaps superior—in the quest for the furs of animals that Europeans sought for their adornment and that of their cosseted ladies.

As Jesuit missionaries were saving the souls of the Native Americans in the Great Lakes region and Canada, French fur traders and Indians were collaborating in the rapidly growing fur business. And it was a Native American woman who rose to the pinnacle of a trade in which only the strongest prevailed.

Beginning in the 1670s, British and French mercantile firms sent gift-bearing agents each year to Mackinac island to trade for beaver, muskrat, otter and fox pelts with the Indians. Mackinac became one of the most popular trading posts in America, scene of an annual spring rendezvous that became legendary in Northern Michigan for its rollicking, roistering, hard-bargaining heyday.

The heritage of fur trading on Mackinac is personified by the name Astor, the New York family of tycoons whose presence on the island helped them outdo the Europeans in acquiring the animal riches of the North Woods.

If and when you jump on the ferry in Mackinaw City and the mist of the straits clears to reveal rocky cliffs, you might reflect on the tragic life of the late, lamented Colonel John Jacob Astor IV, who went down on the *Titanic* in 1912…

…and the historic intersection of his great-grandfather John Jacob Astor with the most famed female fur trader of early Michigan, Madame Magdelaine LaFramboise.

After the last glacier retreated eleven thousand years ago, natives prowling the straits saw an island looming under the high bluffs.

They called it *mish-la-mack-in-naw*, or "big turtle," marveled at its unusual natural limestone formations and found labyrinthine caves where their dead could find eternal solitude.

French-Canadian explorer Jean Nicolet no doubt saw Mackinac during travels on behalf of Samuel de Champlain, governor of Canada, in 1634.

Jesuit missionary Jacques Marquette preached to the Mackinac Straits Indians in 1671, and soon after, the area became the most important French western fur trade site.

After the British acquired the straits following the French and Indian War, English major Patrick Sinclair chose those high bluffs for the site of his Fort Mackinac in 1780.

That was about the time Madame LaFramboise was born at Fort St. Joseph near what is today the city of Niles. Her father was French-Canadian trader Jean Baptiste Marcot, and her mother was Marie Nekesh, granddaughter of Odawa chief Kewinoquot.

Dr. Keith Widder, island historian, described Madame LaFramboise: "A woman of Odawa and French-Canadian ancestry, she took control of her husband's fur-trading business upon his death in 1806."

Her husband, Joseph, was killed in an argument with Indians over whiskey. Traveling throughout Michigan, she became a prosperous fur merchant and maintained a home on Mackinac Island. Her business was said to rival that of wealthy socialite John Jacob Astor, operator of the American Fur Company, which thrived in the years after the War of 1812.

Committed to social causes, she cared for the poor, helped establish schools for Native American and Métis children and supported the island's Roman Catholic church. In the 1820s, she donated a portion of her land for the building of Ste. Anne's Church, which still sits next to her house. A history posted by ancestry.com noted: "She was so successful, that John Jacob Astor decided to quit competing with her, and, in 1818 he bought her out. She was able to live in great comfort for the rest of her life."

Madame LaFramboise died in 1846 and, along with her daughter Josette, rests in a grave in a garden next to the church. Josette died shortly after her marriage to the commandant of the fort, Major Benjamin Pierce, brother of U.S. president Franklin Pierce. The entrepreneur's 196-year-old home was converted to an inn, the Madame LaFramboise Harbour View Inn, which remains a popular island hostelry.

The home and headquarters of Astor's father, William Backhouse Astor, also survives. The name *Astor* is memorialized in the elegant Waldorf-Astoria Hotel in New York City and in the grandiose life of John Jacob Astor IV, great-grandson of the tycoon. That glittering life came to its stunning conclusion in the North Atlantic a little over one hundred years ago when an unsinkable ship named *Titanic* sank after hitting an iceberg.

At the time, Mackinac Island was beginning to come into its own after transitioning from fur trading to tourism—on which it still thrives.

The Astor House fur trading post remains an island sightseeing attraction, just as it was a magnet for natives and French voyageurs more than a century ago.

Brenda Horton of mackinacblog.com related the following about Astor IV:

> *He was the wealthiest person on the sinking ship, and history recounts that he asked to be allowed to follow his wife into a lifeboat because of her "delicate" condition. When he was told there simply were not enough*

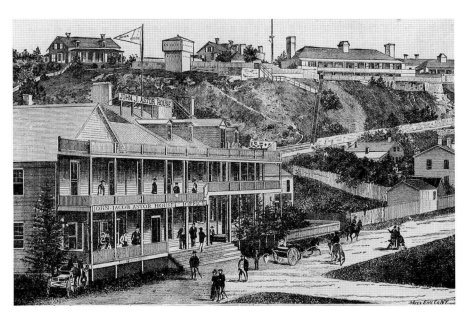

The John Jacob Astor House on Mackinac Island was a hotbed during fur trading days. *Courtesy of the Library of Congress.*

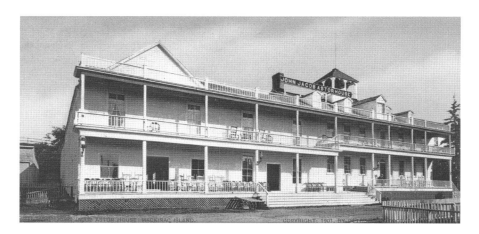

A postcard of the Astor house. *Courtesy of the Library of Congress.*

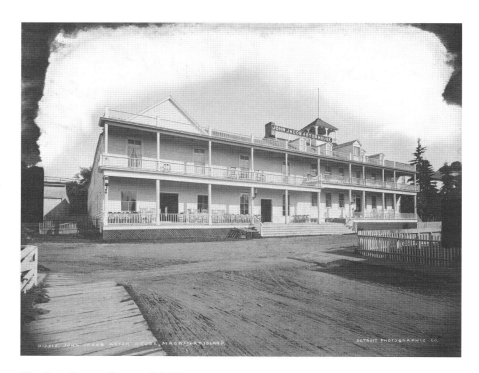

The Astor house. *Courtesy of the Library of Congress.*

lifeboats, and women and children only could board them, it is said that Astor gave his wife his gloves and moved aside.

At his death that night, as owner of the Waldorf-Astoria Hotel, as an author and inventor, and coming from one of the wealthiest families in history, his net worth was $37 billion dollars.

Colonel Astor, the paragon of two islands—Manhattan and Mackinac—was so confident the *Titanic* would never sink that he cut his life jacket to shreds in a show of bravado.

He scorned the lifeboat until the awful reality was confirmed by rising waters submerging the huge vessel.

Astor was one of the wealthiest men in the world, and he had been commissioned a lieutenant colonel in the U.S. Army in the Spanish-American War. When Astor married Madeleine "Pookie" Force, there was considerable public disapproval, as he was forty-seven and Pookie still in her teens. He had divorced his first wife and mother of two children, Ava Willing, daughter of a Philadelphia Mainline family.

To escape the glare of unfavorable publicity and the tut-tuts of Edwardian disapproval, the May-December couple fled to Europe.

They soon tired of the continent, and she was pregnant, so they booked passage in the French port of Cherbourg to return to the States aboard a vessel whose name would live in human memory—*Titanic*. As the ship's band played "Nearer My God to Thee," Astor and more than 1,500 others went to their deaths in the deep.

DID ECONOMIC FERMENT
OF NORTHERN MICHIGAN
SPAWN MCKINLEY'S ASSASSIN?

By the late nineteenth and early twentieth centuries, Eastern European immigrants had arrived and were acquiring former Indian lands for farms—land of their own they had sought so long after decades of their families in serfdom. But they faced a new kind of serfdom in their adopted homeland.

Conditions were extremely harsh on farms and in the sawmills where many Polish immigrants worked. For example, German farmer Albert Moliter, a tyrannical taskmaster on his farm near Rogers City, was murdered by twelve of his laborers tired of his mistreatment, long hours and low wages. One of the workers was reported to be Paul Czolgosz, who had brought his family to Posen from Detroit in 1880. He was an adherent of the socialist movement that had emerged in Detroit in the 1870s and grew with lumber mill workers strikes in 1885 in Bay City, Saginaw and Muskegon, fostered by the Knights of Labor. "Ten hours or no sawdust" was the cry of strikers all over the state.

That was the environment under the banner of Social Darwinism—survival of the fittest—that spawned Leon Czolgosz, whose family was living in Alpena by the 1880s. Czolgosz suffered ethnic oppression and exploitation wherever he went, from Pittsburgh to Cleveland—the American dream was a nightmare for him and others of his ilk.

The boy whose personality had been formed out of the social ferment of Northern Michigan entered the history books in 1901 when he shot and killed President William McKinley. McKinley's reelection in 1900 was seen

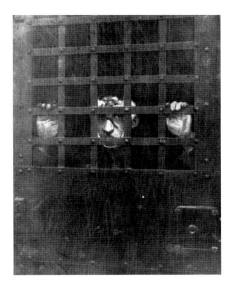

Leon Czolgosz, imprisoned and facing execution for assassinating President William McKinley. *Courtesy of the Library of Congress.*

as a triumph for capitalism, as he had campaigned as the champion of prosperity. Six months into his second term, the president attended the Pan American Exposition in Buffalo, New York, an event dedicated to the glories of modern technology.

On September 6, 1901, McKinley, standing on the steps of the Temple of Music, was shaking hands with members of the public. One person in line was not a well-wisher. Leon Frank Czolgosz was concealing a pistol in his right hand under a handkerchief; the assassin fired twice at close range.

The first bullet did little damage and was easily removed. The second missile passed through McKinley's stomach and kidney and buried itself in his back muscles. Here is where one of the displays at the exposition, a newly invented X-ray machine, might have saved the president's life—had doctors the foresight to use it. However, side effects of X-rays were suspect, so the machine was never employed. Neither were light bulbs—prominent in the exposition's displays but lacking in the emergency room. Rather than risk surgery, the doctors decided to leave the bullet in the president's body and trust in luck.

They had neither foresight nor luck in this instance. After lingering for a week, McKinley went into shock as a result of gangrene in the wounds. He died on September 14, 1901, and was buried in his hometown of Canton, Ohio.

New technology did, however, play a part in the story after all. Another technological marvel, the electric chair, "Sparky," was used to execute the assassin—sidelining both the gallows and the traditional execution method of hanging.

Czolgosz, when interviewed after the assassination, complained there was no prosperity for the poor and justified his act, snuffing out the life of the symbol of capitalism, President McKinley. "It was right to kill him," the slayer told psychiatrists who queried him about the murder.

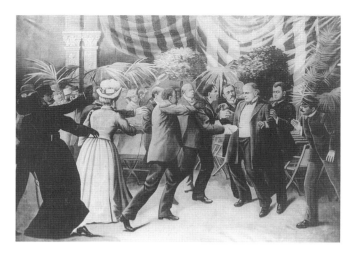

With his pistol wrapped in a handkerchief, anarchist Leon Czolgosz shot President William McKinley in a crowded exhibition room at the Pan American Exposition in Buffalo in 1901. *Courtesy of the Library of Congress.*

McKinley's death elevated Vice President Theodore Roosevelt to the presidency. Roosevelt was a Progressive Republican who advocated workers' compensation, unemployment insurance, breaking of trusts, regulation of railroads and conservation of natural resources.

So, did we ironically, though tragically, get TR and the Progressive movement because Leon Czolgolz had emerged from the social ferment of Northern Michigan and killed McKinley? Some might aptly make that case.

DEER HUNTERS STALLED FOR HOURS AT THE STRAITS SPURRED CONSTRUCTION OF BIG MAC BRIDGE

W e've only had the Mackinac Bridge since 1958.
But did you know it took seventy years from the time the idea was conceived to get it built?

Deer hunters stalled for miles waiting for ferries to the Upper Peninsula finally stirred authorities to get the span built. In November 1954, the lineup of vehicles on US-27 stretched sixteen miles from Mackinaw City to Cheboygan and nine miles on US-31, totaling twenty-five miles of cars waiting to get across the straits, and the wait lasted thirty-nine hours, noted the *Cheboygan Daily Tribune*.

Hunters played cards and built fires while they endured the boring wait, no doubt bitterly grousing. Every mile of cars on the highway meant a wait of an hour to get on the ferry.

The first plan to build a bridge across the Straits of Mackinac had been broached 128 years earlier. Yes, tycoon Cornelius Vanderbilt, a board member of the Grand Hotel on Mackinac Island, posed the idea at the group's first meeting on July 1, 1888: "We now have the largest, well-equipped hotel of its kind in the world for a short season business. Now what we need is a bridge across the Straits."

In 1884, a St. Ignace store displayed an artist's conception drawing of the Brooklyn Bridge, dedicated the year before, and captioned it: "Proposed bridge across the Straits of Mackinac."

In 1920, the state highway commissioner envisioned a floating tunnel from the mainland to the island. Another idea was for a series of bridges and causeways from Cheboygan to Mackinac Island.

In 1923, the Michigan legislature passed an act setting up the state ferry service. The steady growth in traffic was slowed only in the Depression year 1937. From 10,000 vehicles in 1923, traffic across the straits grew to 274,000 in 1937.

In 1928, Governor Fred Green ordered a feasibility study of the bridge proposal. With cost estimated at $30 million, the plan was dropped. The Mackinac Bridge Authority was established by the legislature in 1934 with the thought that revenue bonds could be issued to finance construction of the proposed bridge.

In 1939, the State of Michigan published a booklet with dramatic pictures of the ice-bound straits, ferry boats stuck and passengers forced to walk to shore. The publication was a report of the Mackinac Straits Bridge Authority of Michigan, somewhat of a misnomer, as there was not to be a bridge for nearly another twenty years.

The book opined:

> *Melodramatic yet grimly real is the regularly recurring spectacle of ice-locked ferry boats in Michigan's Straits of Mackinac. As recently as last month this scene was re-enacted when jam-packed floes defied the dogged pounding of ferry boats. Faced with the prospect of indefinite delay amid anything but comfortable circumstances ferry passengers abandoned their cars and truck and, like Eliza crossing the ice, made their precarious way over treacherous paths to shore.*

No doubt the publication was intended to stir the hidebound Michigan legislature to action, but it didn't work, despite further moving appeals:

> *Sick men in an ambulance were forced to wait more than 24 hours for an opportunity to cross this narrow stretch of water. A son hurrying to the bedside of his dying mother was trapped for hours in the ice jam.*
>
> *There could be no better evidence of need for a bridge or tunnel than the picture of a score of men and women climbing from the decks of a ferry boat to stumble across the jagged ice-field as the only means of completing their crossing.*
>
> *Thousands of vacationists have been left stranded for hours at a time, not only on the docks but even on the highways approaching the straits. The*

situation is especially acute each fall when thousands of deer hunters go to the Upper Peninsula. Motorists have been delayed more than 12 hours due to summer congestion and 3 days due to winter weather conditions. In 1957 the lineup of vehicles was 16 miles long, all the way to Cheboygan.

Legislators were ultimately reassured by the successes of New York's George Washington and Iowa's Mississippi River Bridges, as well as California's Oakland Bay and Golden Gate Bridges.

Although Franklin Roosevelt and the Army Corps of Engineers reportedly favored the bridge, his Depression-era Public Works Administration declined to take on the project, and the idea of a seven-thousand-foot-long causeway from St. Ignace also died aborning.

Red tape wrapped the project when it was found negotiations with the War Department on matters pertaining to national defense and navigation clearances were necessary for any project linking the two peninsulas.

World War II delayed planning that was gaining steam for a double-suspension span. In 1947, the bridge authority was abolished by the legislature, no doubt frustrated by the lack of progress.

A citizens' committee got the authority reinstated in 1950. The new law required consultation with the world's foremost long-span bridge engineers and traffic experts on the project's feasibility.

In 1953, the legislature agreed to have the estimated $417,000 annual operating and maintenance cost paid out of gasoline and license plate taxes. That paved the way for private investors to offer and sell $99.8 million worth of bonds.

Ground was broken for the Mackinac Bridge on May 7, 1954, in ceremonies at St. Ignace and Mackinaw City.

Dr. David B. Steinman designed the bridge. Merritt-Chapman & Scott mobilized the largest bridge construction fleet ever assembled to build the foundations. U.S. Steel furnished the steel, and its bridge division built the five-mile-long bridge opened on November 1, 1957.

Richard DeMara of Bay City was among hundreds of ironworkers on the job. Five men, including three ironworkers, died during the construction phase. In 1980, ironworker J.C. Stillwell established a museum at Mama Mia's Pizzeria in Mackinaw City and has an original thirty-minute movie of construction (see www.ironfest.com/bridgemuseum.html).

The Mackinac Bridge is considered one of the world's most beautiful bridges and is the longest suspension bridge in the Americas, with a total suspended length of 8,614 feet. It is the world's third-longest suspension

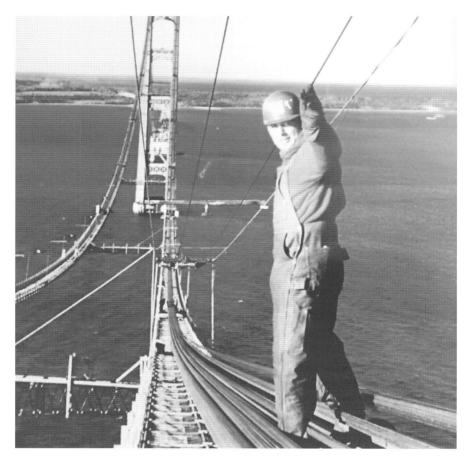

Cheboygan native ironworker Dick DeMara, age twenty-seven, atop the Big Mac girder during bridge construction in 1957. A camera expert, he took hundreds of photos from atop the bridge, except this one, snapped by an intrepid coworker who joined him aloft. *Courtesy of Dick DeMara.*

bridge. The Mackinac Bridge (affectionately called Big Mac) connects Michigan's Lower and Upper Peninsulas across the Straits of Mackinac linking Lakes Michigan and Huron. It was touted as "the longest bridge in the world," and the *Cheboygan Daily Tribune* issued a special five-section, thirty-two-page "Mackinac Bridge Dedication Festival Edition," headlined "Thousands Starting for Festival."

The bridge was completed on November 1, 1957, and opened to the public and dedicated during a three-day festival on June 26–28, 1958.

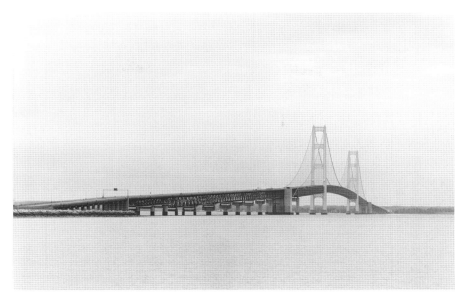

"Big Mac" Bridge, a five-mile span opened in 1958 to great fanfare, links the Lower and Upper Peninsulas of Michigan across the Straits of Mackinac. *Courtesy of the Library of Congress.*

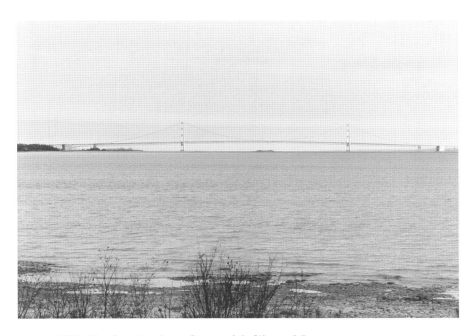

A view of Big Mac from the shore. *Courtesy of the Library of Congress.*

The festival committee was headed by President Neil Downing of Mackinaw City. A 140-unit parade held in Mackinaw City included tanks, howitzers, Nike and Redstone missiles and twenty bands, including the Fifth Army Band.

There were several flyovers of military planes, and an estimated 2,500 military personnel participated. Aboard the Mackinaw City float was five-year-old Bridget Paquet, born the day ground was broken for the bridge, May 7, 1953, to Mr. and Mrs. William Paquet of Mackinaw City.

THE TUMULTUOUS LIFE AND DISAPPEARANCE OF JOHN TANNER, RIVAL OF SCHOOLCRAFT

O ne of the most amazing tales of Indian captivity started right here in Michigan and emerged from the mists of history. Mackinac Island and Sault Ste. Marie are prominent in the story.

Some of the outstanding figures in Great Lakes fur trading history flow in and out of the Tanner captivity narrative, including famed Indian agent Henry Rowe Schoolcraft and the notorious Kish-kaw-ko (The Crow), whose name survives on Crow Island near Saginaw. The Crow, a Saginaw Ojibwa, and his father, Manito-o-gheezik, kidnapped Tanner, then age nine, from his father's cornfield in Boone County, Kentucky, in 1789. Taken first to Detroit and then to Saginaw, young Tanner was sold to a female Ottawa chief, Net-no-kwa, who adopted the boy.

Living with the Ojibwa and other tribes in the Great Lakes and Red River (Minnesota) areas, Tanner's perspective gradually changed. He even forgot how to speak English and was not fluent in French.

Working as an interpreter of Indian languages at Sault Ste. Marie and Mackinac, the quarrelsome, untamed Tanner ran afoul of an even more savage—and politically connected—Schoolcraft. "Schoolcraft and Tanner shared two potentially explosive traits of character: an excitable temper and an unusual degree of determination," observed John T. Fierst of Central Michigan University's Clarke Historical Library in a 1986 *Minnesota History* article.

Fierst concluded that Tanner's turbulent years at Sault Ste. Marie living across cultures were caused by his flawed self-image as an Indianized white

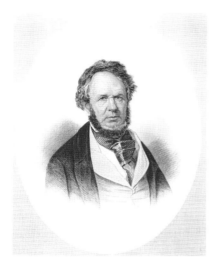

Henry Rowe Schoolcraft (1793–1864), a noted Indian agent stationed at one time at Mackinac Island. He was a scholar who wrote extensively about Indian lore. He also was an explorer of the Mississippi River. *Courtesy of the Library of Congress.*

man. Tanner was literate and wise enough to document his story with help from Dr. Edwin James, an army medical officer on Mackinac Island. The work was completed in 1828 when Tanner left for New York, sold the book to the Carvill publishing house and had his portrait painted.

Fired by government agent Colonel George Boyd when he left the Sault for New York, Tanner was hired by Schoolcraft on his return. The work was the same: translating for Indians, white government agents and fur traders.

Tanner and Dr. James collaborated on an Ojibwa New Testament, and Tanner's *Narrative* was translated into French and German and reprinted in 1956 and 1994.

The book, originally published in 1830 by Carvill, provides insight into Indian customs that may have application to unsolved murders in the Harbor Springs area in the 1960s. (Richard Robison's family of six was murdered after Robison had given gifts to a neighboring Native American whose son had been killed in a motorcycle accident that might have been a youthful prank gone horribly wrong. Speculation lingers that the murders may have been triggered by an ancient native tradition, although a thieving employee of Robison's advertising firm was suspected.) Tanner recalled an incident in which a young Ottawa man covered in blood and carrying a knife was brought into his lodge. "In the morning, having slept soundly, he was perfectly unconscious of all that had passed," Tanner wrote. "He said that he believed he had been very drunk. He was astonished and confounded when I told him he had killed a man. He expressed much concern, and went immediately to see the man he had stabbed, who was not yet dead, but was manifestly near his end."

The assailant "made up a considerable present, one giving a blanket, one a piece of strouding, some one thing, and some another. With these he immediately returned, and placing them on the ground beside the wounded man, he said to the relatives, who were standing about, 'my friends, I have,

as you see, killed this, your brother, but I knew not what I did. Drunkenness made me a fool, and my life is justly forfeited to you. My life is in your hands, and my present is before you, take which ever you choose.'" Tanner continued: "He then sat down beside the wounded man, and stooping his head, hid his eyes with his hands, and waited for them to strike." The mother of the man he had wounded, an old woman, came forward, and said "'We wish not to take your life.' She took the presents, and the whole affair being reported to Gen. Cass, he was satisfied with the course that had been taken."

The key aspect of this tale relating to the 1960s murders is the offering of gifts by a relative of the murderer—without realizing the implication of the gesture—to the relatives of the person who had been killed. That may have been a clear signal to the victim's family about the identity of the perpetrators of the murder. However, in this case, retribution was exacted in a most terrible way. Indian traditions in that regard would have had to persist over a century from Tanner's time to the mid-twentieth century, but such are the lasting memories of those who cling to old customs.

Most of the turmoil in Tanner's life revolved around his four marriages and attempts to keep his children with him. In one case, he was wounded in an ambush by Ojibwa in league with his first wife. Even though crippled by

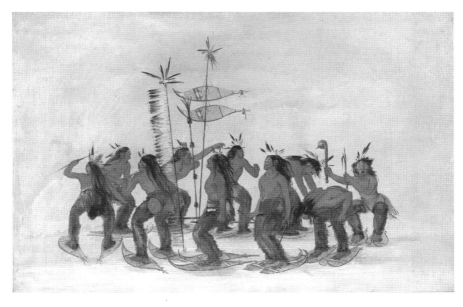

Ojibwa Snowshoe Dance, an ancient Ojibwa tradition performed at the first snowfall every year since time immemorial. Painting by George Catlin, 1835. *Public domain.*

his wounds and nearing fifty years of age, Tanner was able to get another job as an interpreter with Schoolcraft, but only through the influence of territorial governor Lewis Cass.

The ensuing drama that would end the Tanner story would involve conflict between Schoolcraft, Baptist missionary Abel Bingham and Schoolcraft's sister Charlotte, also an interpreter.

The government annuity paid to the Baptist preacher for running an Indian boarding school at the Sault inserted a financial issue into the fray. The Indian agent wanted control over the Baptist preacher's expenditures; the implication was of wrongdoing.

"Schoolcraft pushed through the Michigan Legislature an act to remove Tanner's daughter Martha from his custody and in 1832 Tanner's third wife and their son were also seized from him," recounted *American National Biography Online*.

In his memoirs, Schoolcraft described Tanner as "more suspicious, revengeful and bad tempered than any Indian." Tanner remained in Sault Ste. Marie and took a fourth wife, an Ojibwa woman. In 1846, he was suspected of burning down his own house and murdering Schoolcraft's brother James. He fled into the wilderness and disappeared.

COMEBACK OF GRAY WOLVES IGNITES DECADES-OLD POLITICAL CONFLICT

Wolf howls have been heard across Northern Michigan since ancient times, but now their plaintive calls are for survival, as man has renewed hostilities against the newly revived species.

The history of the wolf in the Great Lakes parallels the history of conservation in the United States, several writers have observed. The Great Lakes region was the only area in the United States where the wolf was never completely eradicated, but their Michigan numbers were reduced to a few dozen in isolated packs and scattered lone individuals.

By 1960, a viable wolf population no longer existed in Michigan. In 1964, wolves were given full legal protection in the state and listed under the Federal Endangered Species Act (ESA) in 1974. The Michigan Department of Natural Resources (DNR) gained management authority over wolves when the species in the Great Lakes region was removed from the Federal Endangered and Threatened Species List in 2007.

In the early 1990s, gray wolves began migrating to the Upper Peninsula of Michigan through Wisconsin and Canada, according to state biologists. In recent years, a few gray wolves have been spotted in the Lower Peninsula, likely having crossed the frozen Straits of Mackinac.

The latest census of *Canis lupus* (gray wolves), taken in the winter of 2015–16 by the U.S. Fish and Wildlife Service, showed 618 wolves in the Upper Peninsula and 3 on Isle Royale.

A federal court ordered that wolves in the western Great Lakes area (including Michigan, Wisconsin and Minnesota) be relisted under the Endangered Species Act as of December 19, 2014.

Gray wolves have been the subject of controversy, as environmental concerns have grown through the years. *Courtesy of the Library of Congress, Pearson Scott Foreman.*

Native Americans coexisted with wolves for centuries, considering them sacred clan animals and part of their spirit world. But just as the forests and fisheries were depleted by the European settlers, the wolves came under attack until they neared extinction.

Wolves killed cattle and deer, and their deep-throated nocturnal howls put fear into the hearts of all who ventured into their lairs—the woods of Northern Michigan and other Great Lakes states. Human fear of wolves is real: a pioneer history of Michigan included an account of how an early settler escaped a wolf bent on carnage only by hiding under a huge cast-iron kettle in the snow outside his cabin. With a hatchet, the settler ended the threat by chopping off the toes of the carnivore as it dug furiously under the kettle, sending it bleeding and in pain back to its den. Through the years, only rare incidents of wolves killing humans have been reported in Michigan.

SecretsofSurvival.com reported, "Wolves are efficient killers, killing large game animals like moose, elk, caribou, deer, and bighorn sheep as well as small mammals like boar, birds, and lizards, eating up to 20 pounds of meat in one sitting. They most often travel and hunt in packs ranging from approximately 6–10 wolves, sometimes larger." In 2014, wolves killed about twenty-six cattle and seventeen hunting dogs in the Upper Peninsula of Michigan—the harsh winter made access to deer more difficult.

The removal of wolves became national policy—ordered by Congress—which placed the welfare of the carnivore under the federal Bureau of Biological Survey (BBS) beginning in 1914. That policy held sway with little opposition until the 1930s, when the American Society of Mammologists—which considered wolves valuable for observation and scientific study—arose to mount a defense of the canine carnivores.

In 1931, the "father of American conservation," Aldo Leopold, also stepped forward as the defender of large carnivores, including wolves, in his landmark "Game Survey of the North Central States." Calling for a rational wildlife approach based on scientific facts, Leopold asserted that "rare predatory species should not be subject to control."

In recent years, policy toward wolves has see-sawed between protectionism and eradication. In Michigan, hunters often view wolves as just another elusive, desirable target, while environmentalists take the opposite approach—cheering their comeback and advocating for growth of the canine carnivore population.

Defenders of Wildlife, a lobbying group in Washington, D.C., takes a positive stance on wolves:

> *Wolves play a key role in keeping ecosystems healthy. They help keep deer and elk populations in check, which can benefit many other plant and animal species. The carcasses of their prey also help to redistribute nutrients and provide food for other wildlife species, like grizzly bears and scavengers. Scientists are just beginning to fully understand the positive ripple effects that wolves have on ecosystems.*

Michigan voters decisively turned down wolf hunting in a 2014 referendum. Under current laws, wolves can only be killed in the state if human life is in jeopardy. Mock howls went up from the back-benchers in the Michigan legislature on December 15, 2016, when a bill to allow hunting wolves if federal protections are removed was passed. Wolf hunting advocate Senator Tom Casperson, a Republican from Escanaba, wore a wolf skin hat to publicize his stance. Upper Peninsula solons introduced a comic attempt to shift the six-hundred-plus wolves in that section of the state to the Lower Peninsula, one legislator joking they should share the predatory beasts. "It's Christmas-time and us Yoopers share the love," Representative Scott Dianda, D-Calumet, said. "Everybody should enjoy what we have."

What side are you on?

AFTER 117 YEARS, CHEBOYGAN BURT LAKE INDIANS STILL SEEK JUSTICE FOR STOLEN LAND

S moke has not cleared for more than a century after the infamous "Burt Lake Burnout" in 1900 in Cheboygan County.

But the Burt Lake Band of Ottawa and Chippewa Indians is hoping a federal court in Washington, D.C., will finally recognize the tribe and grant it justice.

Former member of Congress Bart Stupak is one of three attorneys representing the group, once known as "the Cheboygan Band," as members attempt to reclaim their valuable Indian Point property and their tribal heritage, despite seemingly endless opposition by the U.S. government.

In 2013, Richard Wiles, a researcher for the Petoskey Library, published a comprehensive review of the case in the *Mackinac Journal*. Wiles concluded, "The depopulation and dispersion of the Burt Lake Indians forms one of the darkest pages of American history and proves the utter failure and weakness of the government's Indian policy in the past."

Mike Norton of the *Traverse City Record-Eagle* wrote in 2000:

> *John McGinn was a timber speculator with friends in high places, and he had his eye on the Point. Using loopholes in the state's land acquisition laws, he "bought" the land at a tax sale in 1898, and on Oct. 15, 1900, while most of the male villagers were in town getting their paychecks cashed—he moved in with Cheboygan County Sheriff Fred Ming. Herding the elders, women, and children out into the cold autumn rain, they ordered everyone off, removed the household goods, doused the houses with kerosene, and set them afire.*

Only three cabins and the church built in 1838 by Bishop Frederic Baraga remained.

William Sydow, a farm boy who was fifteen at the time of the incident, told the *Detroit News* in 1969, "The women and children sat in the road and watched their homes burn down. There was nothing they could do. Their men were away. We thought it was all wrong. But we didn't think there was a thing we could do."

Some of the members of the twenty-three dispossessed families walked thirty miles to Cross Village, and others settled with relatives in the area. Their descendants have futilely petitioned the government to gain tribal recognition and reclaim their land.

The lawsuit targets officials of the Department of the Interior and the Bureau of Indian Affairs (BIA), which in 2004 posted on the Federal Register a blatant manifesto titled "Proposed Finding Against Federal Acknowledgement of the Burt Lake Band of Ottawa and Chippewa Indians, Inc."

The posting amounted to a decision announced before the fact, or before a proper hearing, although it speciously stated challenges would be accepted for up to 180 days.

The government seems to have spent more time and money splitting hairs and micro-manipulating flawed concepts of Indian descendants' trees than rational consideration in its tortuous justification for disapproval. The government's stance seems to key on this statement: "Just 46 percent of the petitioner's 490 members descend from the historical Cheboygan band, and 48 percent descend from John B. Vincent (1816–1903). Although Indians at Burt Lake were acknowledged as a tribe as recently as 1917, most of the petitioner's members do not descend from the previously acknowledged entity."

That appears to be a bald-faced acknowledgment that 46 percent of the Indian band have no rights at all, according to the BIA. "The Burt Lake Band is currently caught in a clear-cut example of arbitrary and capricious behavior by the federal agency charged with handling the United States' relations with sovereign Tribes," stated a complaint filed by attorneys for Venable P.L.C. "The BIA's capricious 'non-decision' was based primarily on the established historical fact that Burt Lake Band's lands were violently stolen from it."

"The old St. Mary's Cemetery is the only remaining sign of a village that served as the social, religious and cultural center of the small Burt Lake Band of Ottawa and Chippewa Indians," wrote Norton.

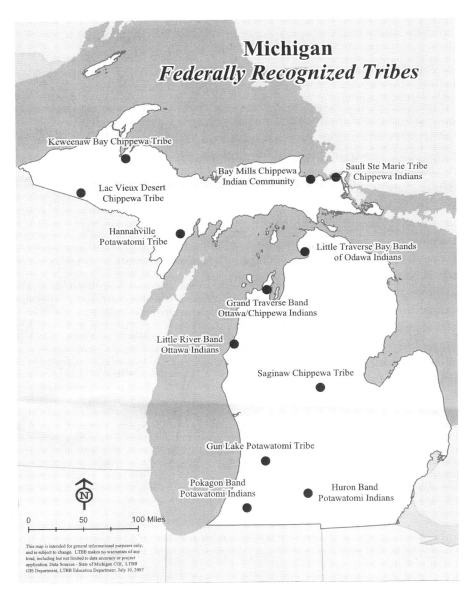

Many of the Indian tribes in Michigan remained when repressive government policies under President Andrew Jackson forced most tribes in the South to Indian Country, Oklahoma. *State of Michigan.*

"These were no 'backward savages,' they were hard-working Catholics who farmed, fished, and drew paychecks as lumberjacks and millwrights for local logging operations. And this land was theirs, not by some vague aboriginal right or a promise from far-away Washington. They had bought and paid for it themselves under the white man's own laws.

"In 1836, the federal government had promised them a 1,000-acre reservation around Burt Lake; when it failed to deliver on that promise, the Indians pooled their money and bought Indian Point for themselves, deeding much of it to the state of Michigan in the belief that they were creating a tax-free reservation."

Developers changed the name to Colonial Point, and today, the area is populated with upscale homes on tree-shaded streets that reflect the prosperous residents, who have, over many years, displaced the natives. Pure Michigan's website blithely advertises "Colonial Point Memorial Forest/ Chaboiganing Nature Preserve," touting it as a place for leisure pursuits like trail hiking. There is no historical marker noting the terrible events of more than a century ago or the Indian heritage of the site.

The site also boasts, "Acreage: 484 acres. Colonial Point is entirely wooded and includes the largest old-growth red-oak stand in the northern Lower Peninsula, with trees up to 150 years old. Chaboiganing Preserve is a mixture of woodlands and open fields. Over 2-1/2 miles of easy trails for hiking and skiing. Located on a peninsula on the west side of Burt Lake."

BRITISH PADDLE 360 MILES TO DETOUR PASSAGE, AVENGE BURNING OF SCHOONER *NANCY*

In addition to the battles for Fort Mackinac on Mackinac Island, considerable and significant naval action took place in the Northern Michigan region during the War of 1812.

However, someone interested in the history of the War of 1812 must travel to Wasaga Beach, Ontario, to find much information about a little-known American triumph in Canada and a reciprocating naval defeat of the U.S. Navy in our waters, marking one of the last gasps of the British in the war. The link between the American outpost at Mackinac and the British stronghold 360 miles south is virtually unheralded but was nonetheless an important one.

Fort Mackinac was a trading post commanding Lakes Huron and Michigan and the West. It had been maintained by the French as early as 1687, but the British, in 1761, were first to properly fortify the fort.

British naval and military establishments on Penetanguishene Bay at Wasaga Beach were a link in the chain of an empire stretching from the Caribbean, Bermuda, Halifax, Quebec, Kingston and York through Penetanguishene to the Upper Lakes and then to the vast areas of western Canada. It was all part of the Royal Navy and British military presence in defense of the empire in the Western Hemisphere.

Penetanguishene was settled by French voyageurs; French is still spoken there, and the sound of old voyageur and canoe songs can be heard. The Ontario city is where a memorial and museum to HMS *Nancy* commemorate one of the final episodes in the war.

The counterattack was the British response to an attack by the United States that burned the HMS *Nancy*, an eighty-foot schooner of red oak and cedar. The schooner was built in Detroit in 1789, when the British held that city, and had been employed constantly on Lake Erie, moving supplies between Detroit and Fort Erie.

The schooner carried 350 barrels of food, clothing, rum, meat, gunpowder, blankets, tools, trinkets, weapons and ammunition. And of course, it carried furs on the return trip.

When the United States declared war in 1812, the *Nancy* was a private trade vessel lying at McIntosh's Wharf at Moy (Windsor) across the St. Clair River from Detroit. It was immediately moved to Amherstberg and requisitioned as a British transport. "Most scholars agree that the war was fought over maritime issues, particularly the Orders in Council, which restricted American trade with the European Continent, and impressment, which was the Royal Navy's practice of removing seamen from American merchant vessels," commented Donald R. Hickey, author of several books on the War of 1812.

The *Nancy* was the object of a search by the last flotilla of American fighting ships to sail the Upper Great Lakes in a warlike situation. The three American ships, *Niagara*, *Tigress* and *Scorpion*, which finally located the *Nancy*, had five hundred men and twenty-four guns, while the *Nancy* was armed only with three guns.

Wood-gathering parties from the American ships stumbled on the *Nancy*, hidden up the Nottawasaga River near a blockhouse. The Americans shelled the British ship over the narrow spit separating the Nottawasaga from Georgian Bay. As Lieutenant Miller Worsley of the British navy was poised to destroy the *Nancy* rather than let it fall into enemy hands, a direct hit on the blockhouse set the ship afire. As it burned to the waterline and sank, the British forces—twenty-two seamen, twenty-three Indians and nine French Canadian voyageurs—escaped into the forest.

Three American ships carried troops that blew up the British vessel and destroyed its cargo, hoping to starve the British garrison at Michilimackinac into surrender. "The fate of the *Nancy* gave the Americans a boost in their quest to gain control of the Great Lakes," commented a British historian.

As the American ships were en route back to Mackinac, the British sprang to their small boats in pursuit. That insult in the waters of British Canada galvanized the small British force to furiously paddle 360 miles from Ontario in small boats to stealthily capture the U.S. vessels *Tigress* and *Scorpion* near Drummond Island. Worsley and his men surprised and

captured *Tigress* at midnight in Detour Passage: "With the help of the British garrison at Michilimackinac they captured that vessel after a severe action including an exchange of fire and sharp hand-to-hand fighting," commented Historica Canada.

The Brits, still flying the American flag, lured an unaware *Scorpion* into position, boarding and capturing it the following day.

The two ships were part of a fleet President James Madison had ordered constructed at Erie to regain control of Lake Erie. Daniel Dobbins and Noah Brown led construction of four schooner-rigged gunboats (*Ariel, Porcupine, Tigress* and *Scorpion*) and two brigs (*Lawrence* and *Niagara*). The ships were constructed between December 1812 and June 1813.

The loss of the *Nancy* was avenged, and both U.S. ships then were taken to Fort Michilimackinac, the British headquarters, near present-day Mackinaw City, until the war ended. *Scorpion* was renamed *Confiance*, and *Tigress* was dubbed *Surprise* for the manner in which it was captured.

Fort Holmes, constructed in 1814 by British soldiers on the highest ridge of Mackinac Island, was originally named Fort George after King George III. When the United States reoccupied the island after the War of 1812, it was renamed in honor of U.S. Army major Andrew Hunter Holmes, killed in the 1814 Battle of Mackinac Island. *Courtesy of the Library of Congress.*

A wall made of wooden pikes at Fort Michilimackinac. *Courtesy of the Library of Congress.*

All this happened on September 3 and 4, 1814, as the second war between the United States and Great Britain was ending. The *Nancy* was at Fort Michilimackinac when the Yanks won the Battle of Lake Erie on September 9, 1813, and Commodore Oliver Hazard Perry messaged: "We have met the enemy and he is ours: two ships, two brigs, one schooner, one sloop."

Historica Canada commented, "Worsley's 'cutting out expedition' (the use of small boats to seize a larger ship at anchor), is a classic case of its kind, notable in the annals of naval history. The American commanders were largely absolved of blame for the loss of the vessels under their command, insufficient signals being specified as the reason." Historica Canada noted that *Confiance* had another part to play: "Worsley, now in command of the Confiance, took that schooner to Michilimackinac in late April 1815, and told the British commandant there that peace terms had been agreed to by Great Britain and the United States." *Confiance* was used as a British survey vessel in establishing the International Boundary and in protecting British and Canadian interests. Both schooners were sent back to Lake Erie, where *Confiance* became the flagship of Commodore Sir Robert Hall. In 1830, they were surveyed and found "very rotten" and retired.

"The War of 1812…was in a very real sense a failure," commented Hickey. "[However], it was an important turning point, a great watershed, in the history of the young republic. It concluded almost a quarter of a century of troubled diplomacy and partisan politics and ushered in the Era of Good Feelings."

COST OF HEMINGWAY'S ONE NIGHT AT THE PERRY HOTEL IN PETOSKEY? SEVENTY-FIVE CENTS!

Later to become an internationally famed novelist and Nobel Prize winner, Ernest Hemingway stayed one night in the Perry Hotel in Petoskey—and it cost him just $0.75. Rooms at the Stafford-Perry now are in the $175 per night range.

No, the hotel now known as the Stafford-Perry wasn't a cheap flophouse; the author was traveling across Northern Michigan in the summer of 1916, sleeping mainly outdoors, sometimes braving rain, on an extended fishing trip with Lewis Clarahan, a friend from Oak Park, Illinois.

The pair of sixteen-year-olds had graduated from Oak Park High School on June 10, 1916, and were off to explore the world—at least the outdoor paradise of Northern Michigan—in celebration.

Hemingway recalled being ecstatic about the fact that the rainbow and brook trout he caught were "good fighters." This presaged his lifelong preoccupation with adventure while fishing and hunting, from trout in Northern Michigan to lions in Africa.

The adventuresome pair visited some less-than-exotic sites—Kalkaska, Cadillac, Onekama, Frankfort, Elberta and Walton Junction (which Hemingway described as "the place that put the junk in junction").

Hemingway's stories about his summers (1899–1921) in Northern Michigan helped shape world opinion about the glories of the area that still enchant visitors today. Some of the stories, however, are not entirely flattering.

Kalkaska is highlighted tongue-in-cheek in Hemingway's short story "The Light of the World." Jack Jobst's meticulously documented 1995 article in

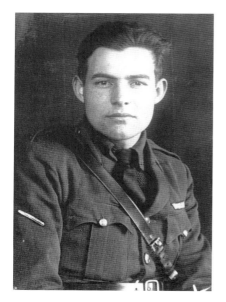

Ernest Hemingway, age nineteen, in a Red Cross second lieutenant's uniform after his return from fighting in the early days of World War I in Italy. He was wounded several times and, upon his return, paid a nostalgic trip to Northern Michigan, where he had spent summers for many years. The war experience was the subject of his novel *A Farewell to Arms*. *Courtesy of the Ernest Hemingway Photo Collection, John F. Kennedy Presidential Library and Museum, Boston.*

Michigan History Magazine described the visit of two teenage boys to a Wild West–type barroom in the pre–World War I burg. The bartender called them "punks" and shooed the boys away from the free lunch table, even though they purchased a nickel beer (obviously before liquor laws would have barred such a purchase by minors).

The new Oak Park High School graduates, however, endeared themselves to the locals by giving away the extra trout they caught. (The Hemingway Collection at the John F. Kennedy Presidential Library in Boston noted that Hemingway favored rolling fish in cornmeal and frying them in shortening with bacon.) An old couple in Mayfield, including a pipe-smoking woman, was described as delighted with their trade of a quart of milk for two suckers about two feet long the boys had caught.

The train ride from Walton to Kalkaska cost the boys thirty-seven cents each, not exactly a bargain, even for those days.

Was it Northern Michigan that shaped the Nobel Prize–winning author or the other way around? His Nick Adams stories were a compilation of tales from the viewpoint of a city boy growing up in a fishing, hunting, vacationing paradise—a theme that perhaps resonated with generations of city dwellers to follow.

Eight previously unpublished Nick Adams stories have been included in the latest (1981) volume, fleshing out Hemingway's boyhood experiences in Northern Michigan. He even confessed his fear of the woods in the opening

chapter, "Three Shots." Startled by a noise in the woods, Hemingway fired a rifle from his tent into the wooded darkness.

The chapter titled "Summer People" is his first fictional account of life Up North and part of the revised Nick Adams stories, still selling well on Amazon after all these years. However, in its review, the *New York Times* was brutal, commenting:

> One of the few completed "new" stories is called "Summer People," in which Nick moves in on a girl who is loved unrequitedly by a friend of his. The story etches the perversity of love—Nick's desire for the girl, hers for him and the supererogatory passion of the third party. There is no justice in the passions of the young, so the lover whose constancy makes him the most deserving becomes the patsy, worthy only of pity.
>
> One wonders, incidentally, if this is the story called "Up in Michigan" that was dropped from "In Our Time" at the insistence of the publisher, Horace Liveright, on grounds of obscenity.

Were Hemingway's works highlighting Northern Michigan just entertainment, or were they a template for an idyllic vacationland life that Americans could aspire to live? He glorified fishing and fast-flowing streams surrounded by thick forests, living lakeside in paradise-like areas—a glorified bucolic existence anyone might imagine in their dreams.

Think of how factory and office workers have streamed out of cities and headed north for over one hundred years. In their minds, Northern Michigan is Nirvana, the Shangri La sketched by Hemingway that helps them escape from the boredom of work, subdivisions, traffic-clogged freeways and bland middle-class existences.

Was that the real draw posed by Hemingway's writings about Northern Michigan? The attraction of civilization-weary city folk to the woodsy, lake-spattered north, as described by Ernest Hemingway, is proven and permanent.

"HOW DO YOU LIKE MY BOOK?" ASKED HEMINGWAY

"NOT MUCH, MOVIE WAS WORSE," REPLIED JACK PARKER

The scene is a bar in a Paris hotel. The year is 1947.

The players: Jack Parker, Saginaw advertising executive extraordinaire, then a radio broadcaster in Europe covering the windup of World War II, and the legendary Nobel Prize–winning author Ernest Hemingway.

PARKER: (not recognizing the big man, beardless at the time): "Just saw a movie, *To Have and Have Not*," (based on Hem's latest book of the same name).

HEMINGWAY: (casually) "How'd you like it?"

PARKER: (allegedly) "Well, I didn't like the book, and the movie was worse. If you ask me, about all Mr. Hemingway sold the movie producers was the title of the story…and whatever they paid him was too much."

HEMINGWAY: (curiously) "Didn't catch your name."

PARKER: "Jack Parker—of ABC. What's yours?"

HEMINGWAY: "My name's Ernest Hemingway."

Parker lamented: "I missed a beautiful opportunity to keep quiet. I saw him every once in a while after that, and every time I did, he'd grin and ask me if I'd read any of his books lately."

The yarn about the awkward meeting of the broadcaster and the author was recounted in Captain Parker's 1986 book, *Shipwrecks of Lake Huron: The Great Sweetwater Sea*, published by Avery Color Studios, Au Train, Michigan.

Parker died in 1984, but the book was published by his son, Philip S. Parker, two years later. Phil wrote the preface, a fascinating biography of his father.

Captain Parker was born in 1916 and grew up in the Tawas area, where he gained a love of the lake that escalated to yachting over twenty-five years, hence his honorary title, Captain.

Parker aimed to chronicle all the shipwrecks in Lake Huron since, well, the beginning of time, approximately one thousand. It includes Bay City's first vessel, the *Esperance*, constructed in 1788 by Louis Tromble, grandfather of pioneers Mader and Joseph Tromble.

Besides the intriguing summary of Parker's life, the book contains a chapter on communications on the lakes stemming from the sinking of the *Titanic* on April 14, 1912, "a tragic accident destined to change the communications status of shipping everywhere." The Radio Act of 1913 requires all vessels carrying fifty or more persons to be equipped with ship-to-shore wireless and licensed operators.

Little gems of knowledge are included, including the wording behind the call letters of the first Great Lakes radio station, WCAF, initiated by the Michigan Limestone and Cement Company out of Rogers City, a designation supposedly taken from "we're calling a friend."

Otto Sovereign's yacht *Old Timer*, stationed at the Saginaw Bay Yacht Club, made that club the first in the world, according to Parker, to house complete electronic ship-to-shore communications equipment. Sovereign was co-founder of Aladdin Ready-Cut Homes, pioneers of the process, and author of *Fifty Million Dollars on a Shoestring*, the fact of the firm's success stated in the title. Aladdin produced seventy-five thousand homes between 1907 and 1977.

Anecdotes about radio were, of course, natural for Parker, who was reared in Otisville and, at age fifteen, became a part-time announcer at Flint's WFDF. He soon moved to Michigan State College in 1934, mainly because of radio station WKAR on campus, where he worked in addition to WJIM Lansing.

Graduation saw Parker becoming program director at WBCM in Bay City. During World War II, Parker became capital correspondent of the statewide Michigan radio network and wangled assignment to Europe as a war correspondent. That was where he awkwardly encountered the legendary author Hemingway.

ABC picked him up, and by V-J Day, our Captain Parker had returned home to record jubilation of two million from New York's Times Square. He became an executive at WSAM Radio in Saginaw and founder of Parker Willox, Fairchild and Campbell Advertising.

GERMAN PRISONERS OFTEN FOUND FRIENDS NEAR MICHIGAN PRISONER-OF-WAR CAMPS

Publicity for a 2009 historical tour outlined the facts of the German prisoners in Michigan:

"During WWII, the Midwest housed about 250 prisoner of war camps for the 380,000 German POWs imprisoned in the United States." (Michigan had 25 camps, some in former CCC barracks.)

"German POWs held in Army-operated camps across the U.S. were sent out to harvest or process crops, build roads and waterways, fell trees, roof barns, erect silos, work in light non-military industry, lay city sewers and construct tract housing, wash U.S. Army laundry and do other practical wartime tasks.

"With the high rate of 19th-century German immigration to the Midwest, many of those who worked with POWs spoke to them in their native tongue. Some had relatives or former neighbors among them. In the process, they formed significant, often decades-long friendships with 'the enemy' and underwent changes as individuals and as a group, thus influencing postwar German values and institutions, and American-German relations. Some POWs later even immigrated to the U.S."

American troops had landed in North Africa on November 8, 1942. It was the first U.S. combat initiative there, known as Operation Torch and led by General Dwight D. Eisenhower. A naval armada dropped them on the beaches of Morocco and Algeria, and the Yanks got behind Rommel's previously dominant Afrika Corps.

According to the History Place (wwwhistoryplace.com), "To prevent the Allies from sweeping to victory in North Africa, Hitler rushed in reinforcements, mainly to halt the American advance at Tunisia. There the very first shots were exchanged between German and American troops in World War II."

The Germans got the upper hand in the first engagement at Kasserine Pass, confirming Hitler's low opinion of American troops. But the fresh American troops, ably led by General George S. Patton, reversed their fortunes in concert with the battle-hardened Eighth Army.

British and American warships and planes now dominated the Mediterranean, isolating the Afrika Korps by disrupting its supply lines. Forced by shortages of ammunition, fuel and food, the entire Afrika Korps and newly arrived reinforcements, an estimated 248,000 men, surrendered to the British and Americans.

According to one source, around six thousand German prisoners of war were posted at the various camps across Michigan. About one thousand POWs were at the five camps in the Upper Peninsula, with the remainder located in the Lower Peninsula.

The Red Cross made periodic inspections of the camps to ensure that the POWs had decent living conditions and were being treated fairly, attention certainly not paid to U.S. soldiers in German custody.

Escape attempts were few, and no German POW from Michigan is known to have made a complete escape from one of the camps. At the Owosso camp, a former racetrack, where about two hundred Germans were held, two local girls helped two prisoners to escape. They were recaptured after a night in the woods. The girls served one-year prison terms for their role in the escape.

"After the war ended the German POWs were sent back to Germany," wrote one observer on the giftbasketsfrommichigan.com website. "Many of the prisoners would have liked to have remained here, but due to regulations they had to return to their home country."

An excellent book on the subject, *Nazi Prisoners of War in America*, by Arnold Krammer, was published by Stein & Day, New York, in 1979. Krammer reported there were 511 camps across the country; however, the book is sadly lacking details on the prisoners in the Michigan camps.

John Pepin, a Marquette newspaper reporter, collaborated with the public television station at Northern Michigan University on a documentary about the camps in the Upper Peninsula.

List of German POW Camps in Northern Michigan:

- Camp AuTrain
- Barryton, Mecosta County
- Camp Evelyn, Alger County
- Camp Germfask, Germfask
- Grant, Newaygo County
- Hart, Oceana County
- Mass, Ontonagon County
- Camp Pori, Upper Peninsula
- Camp Raco, Upper Peninsula near Sault Ste. Marie
- Shelby, Oceana County
- Camp Sidnaw, Sidnaw
- Wetmore, Alger County

IRONWORKER DICK DEMARA RECALLS "HIGH LIFE" OF BIG MAC CONSTRUCTION

Dick DeMara always draws a crowd when he talks about his high life sixty years ago.

DeMara, a longtime Bay Cityan, was one of about two thousand iron workers who helped build the Mackinac Bridge in 1956–57.

He's been giving the same presentation on the building of the bridge for fifty-eight years, without notes or a script. DeMara was a member of Local 25 of the Iron Workers, out of Detroit, actually the International Association of Bridge, Structural, Ornamental and Reinforcing Iron Workers.

At age twenty-seven, DeMara was glad to trade a job working for Plymouth Industries in Cheboygan that had a contract with Argus Camera in Ann Arbor at $1.60 per hour for one at $3.50 per hour, even if it was highly dangerous.

Familiar with cameras after having worked for Argus Camera in Cheboygan, DeMara took pictures of every ship that went under the bridge while he was aloft. Most memorable was the U.S. Coast Guard icebreaker *Mackinaw*. When the *Mackinaw* came to Cheboygan in 1944, DeMara and other students were let out of school for the occasion. Now retired, it is a museum in Mackinaw City.

The *Vacationland* was another of the ships he recalled. It was one of the original state car ferries used before the bridge was built to get folks from the Lower Peninsula to the Upper. The massive ship carried 150 cars at once. After the bridge opened, the *Vacationland* moved around before being sold to a company in Alaska for oil rig support. The ship sank in the Pacific in 1987 while being towed to China for scrap.

Although five workers died while the five-and-a-half-mile-long bridge was being built, DeMara maintains the job was safe. He does admit, however, that prowling about on ten-foot-wide catwalks five hundred feet above the straits in the rain "got a little slick and hairy up there some times."

As an employee of the American Bridge Company, one of the contractors on the $70 million two-year project, DeMara has recollections you won't get reading a standard history of the bridge. He noted that the causeway leading to the bridge was in place long before construction started.

The planned route of the bridge was moved thirty-five feet north toward St. Ignace, accounting for a little crick in its path. There are 340 strands of 2.25-inch cable, amounting to forty-one thousand miles of wire, in the bridge's structure.

The cables were squeezed together into a 24.5-inch-diameter bundle to fit inside the castings of the superstructure. DeMara recalls sliding down the cable bundles on a piece of plywood, which was fine—except for the steel tabs on the wrapping that jutted out from the bundle. "First went the plywood, then the Carhartt's," he quipped.

Workers would take the ferry out to the bridge site from Cheboygan each day. "They wanted to charge us, but we weren't making that kind of money," he joked.

They rode up to the bridge in a basket that was lowered to the waterline. "Now they have elevators," he said.

Caissons 116 feet in diameter were filled with ore from ships that came to the site. Anchor piers were seated 100 feet down. The towers were made in Pennsylvania and were brought by barge to the bridge site. The barges were sunk to put the towers in place, he recalled.

Working high aloft posed difficult problems for normal daily operations. Before carpenters built a high-rise bathroom for the men, people on passing ships were surprised by unpleasant sprinkles, he laughed. "They really didn't know what it was."

The bridge opened on November 1, 1957, when Governor G. Mennen Williams drove the first car across. It was the longest suspension bridge in the world at that time.

Dick was quoted in the *Iron Worker Magazine* when the fiftieth anniversary of the bridge was celebrated in 2007. "If you worked on the Big Mac you worked on the big job. Ordinary men with extraordinary skills did it. I was up on the wire 50 years ago from beginning to end."

DeMara had another career that brought him into the public eye: brigadier general of the Michigan National Guard. He enlisted at eighteen

in 1947 after graduation from Cheboygan High School. In 1954, he was commissioned a second lieutenant; in 1983, he made general.

He was involved in training in Germany during the Korean Conflict and was assigned to help put down the riots in Detroit in 1967.

Born in 1929 in Detroit, Dick DeMara has memories of life activities few can match, especially his high life above the Straits of Mackinac.

STAFFORD SMITH, FROM DESK CLERK TO OWNER

HIS ONLY JOB HAS WORKED OUT WELL

The kindly old gentleman in a "Mr. Rogers" sweater came by, nodding in a friendly manner, as he poured coffee at Stafford's Bay View Inn restaurant.

"Who's that?" my wife, Dolores, and I wondered. "Probably a volunteer or a part-time host," she ventured.

"Sir, I'm looking for the owner, Mr. Stafford Smith, I want to interview him for MyBayCity.com," I asked the old gentleman.

"I'm Stafford Smith," the mild-mannered coffee pourer responded, like Superman coming out of the phone booth after having entered as Clark Kent.

Sitting down with this reporter over a cup of coffee on the front porch of the small Victorian hotel, Mr. Smith explained that he began work at that same place fifty years ago as a nineteen-year-old part-time clerk during the summer. He never left, and working at the inn is the only job he ever had or needed. He first visited the inn in 1957 for dinner with his aunt.

The story of how he returned every summer after studies at Northwestern; worked full time three summers; met his wife, Janice, a Flint native, who worked there as a hostess; and bought the hotel in 1961 is worthy of a Horatio Alger comparison.

Now the avuncular, unassuming Mr. Smith not only owns the Bay View Inn but also the fifty-six-room Stafford-Perry Hotel in Petoskey, the Weathervane Restaurant in Charlevoix and the Pier Restaurant in Harbor

Springs. Recent acquisitions are the Drawbridge Bistro in Charlevoix and Stafford's Crooked River Lodge and Suites in Alanson. The firm is now known as Stafford's Hospitality Inc.

He sketched a little of the history of the inn: "Summer after summer people would come here from steamy areas like Cincinnati, St. Louis and Chicago to get away from the sticky heat," he observed, smilingly refilling my coffee cup. "In 1959, the Mackinac Bridge opened, and people came from all over to see this marvel," he recalled. "I was on the desk then, and we turned over every night," explaining that new guests came every night and left to see the bridge.

Just then, Stafford's trolley arrived, packed with tourists, and Mrs. Stafford alighted, came on the porch and explained that the trolley used to run on Belle Isle in Detroit. "He makes me work," she groused, smiling. When I noted that new trolleys cost about $250,000, he explained that he bought this one well used for $10,000 and refurbished the bargain vehicle, which has served well for several years.

Her "cute little southern accent"—which attracted Mr. Smith—was acquired during a college career at the University of North Alabama–Florence. Smith explained that her twin brother went south on a football scholarship, and "he came home but she stayed and finished."

Mr. Smith's once-in-a-lifetime, golden opportunity came when he was assistant manager of the Bay View; the owner, a professor at Michigan Tech in Houghton, took a new job and decided part-time hotel ownership was too much.

"He couldn't find a buyer, so he set us up in business," Mr. Smith recalled, noting that he bought the hotel in May 1961. Dr. Roy Heath, a chemist who worked on the Manhattan Project (atomic bomb development), had owned the hotel for eight years.

"The stars were aligned for us," said Mr. Smith, "we were both twenty-two when we took over."

They tore the lobby apart and redid it, winterized the place and got in on the skiing and snow sports boom early. The entire hotel was refurbished little by little, the Smiths doing some of the work themselves.

"This place was like a big cottage with no foundation, sitting on cedar piers," he said. "Putting in a foundation was a major undertaking, and we spent as much in the 1963 renovation as we paid for the hotel."

The Bay View is like a sixteen-room mini Grand Hotel. It was built in 1886 as one of only two inns at Bay View, which continues its long history from the days of the Chautauqua summer retreats. Originally the Howard

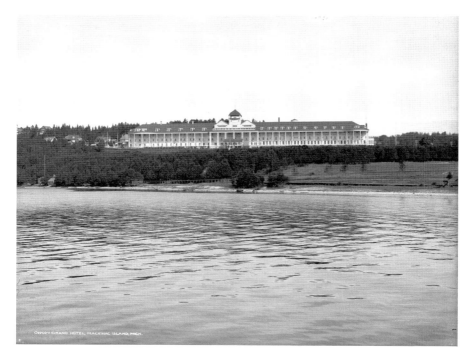

The Grand Hotel on Mackinac Island, a 130-year-old wood-frame structure that is an icon of Northern Michigan and a noted political gathering place. The 660-foot-long porch was recently completely rebuilt. The 393-room hotel was opened on July 10, 1887, by the railroads and a ship line and was touted as the world's largest summer resort hotel. *Courtesy of the Library of Congress.*

Hotel, after owner John Wesly Howard, later it became Roselawn. In 1935, the name Bay View was attached, and it stuck.

There are no TVs in the inn, which has banned smoking for years and has diaries in the rooms for guests to write comments, like, "We are looking forward to vespers on Sunday night," by a couple from Kettering, Ohio. Because of weddings and corporate meetings, the inn has had a liquor license in recent years.

The Smiths acquired the Pier Restaurant at Harbor Springs in 1970, the Perry Hotel in 1989 and, a little later, the Weathervane Restaurant in Charlevoix, a picturesque building that originally was a gristmill.

How Mr. Smith acquired the Perry is a story worthy of a crime novel. He was brought in by Old Kent Bank to evaluate the Perry after the previous owner, Arthur J. Curry, went bankrupt in 1988. Desperate to raise cash to

A view from the Grand Hotel veranda. *Courtesy of the Library of Congress.*

keep the hotel going, Curry had kidnapped the wife of a wealthy industrialist, hoping for a ransom. Curry was caught and sent to prison.

The Hemingway Society uses the Perry as a main attraction since it was an early hangout of their hero, famed writer Ernest Hemingway. "Serious Hemingway fans come from all over, and the connection is good for us," Mr. Smith related.

My wife, Dolores, and I took the Hemingway tour, sponsored by Central Michigan University. A visit to the family's Walloon Lake cottage was narrated by Hemingway's nephew, the colorful, ebullient Ernest Hemingway Mainland, a retired insurance executive. Mainland and Mr. Smith are both longtime Rotary Club members, and one of the two Petoskey clubs meets at the Stafford Inn.

Mainland is featured in a video production, *Ernest Hemingway: Life in Michigan*, celebrating the years "Ernie" spent in Northern Michigan and his Nick Adams Stories set in Petoskey and nearby Horton Bay. The Michigan Humanities Council is using Hemingway's books as part of its "The Great Michigan Read" reading promotion program.

Bay View is one of America's five remaining Chautauqua resorts, which offer four pillars of activity: religion, recreation, arts and education. Houses at Bay View were rapidly built without kitchens, and the social set that summered there took their meals in a main dining building.

"In 1876, the Grand Rapids and Indiana Railroad Company donated three hundred acres of land near Petoskey in the Little Traverse Bay to a Methodist group for religious and social purposes," wrote Camden Burd in *Michigan Historical Review* (Fall 2016). "The Bay View Association launched resort life in northern Michigan."

In 1884, the *Bay View Herald* lauded the northern resort's salutary effects on hay fever, also expansively noting the area offered "educational and religious advantages to uplift humanity, 'physically, morally, intellectually and spiritually.'"

Bay View is a privately-owned association with leasehold memberships affiliated with the United Methodist Church. The 350 acres are part of Bear Creek Township and are assessed on one tax bill. There are 444 cottages and two hotels.

According to the lease and association rules, the cottages may not be occupied from November to May. Since 1968, Mr. Smith has had a deal with the association to remain open all year. So, members who come up to check their properties often stay at Stafford's Bay View Inn, he said. The Smiths spend seven months a year in Arizona and return to work their properties during the gorgeous Northern Michigan summers.

NOVEMBER REQUIEM

DEADLY MONTH FOR SHIPS ON THE GREAT LAKES

The sinking of the Edmund Fitzgerald *and the loss of her 29-member crew during a violent fall storm on November 10, 1975, just northwest of Whitefish Point in southeast Lake Superior was at the time the worst maritime disaster on the Great Lakes in nine years. Of the more than 1000 ships that have found their graves under the icy waters of the Great Lakes, the* Fitzgerald *is still the largest ever to go down. Just like the* Titanic, *the demise of this seemingly invincible vessel has attracted widespread attention and inspired songwriters and authors to tell her story.*
—*U.S. National Oceanic and Atmospheric Administration*

*N*ovember Requiem: The Documentary, is an award-winning documentary film on the loss of the Great Lakes freighter *Carl D. Bradley* on Lake Michigan in 1958 and its impact on the close-knit community of Rogers City, Michigan.

The steamship *Carl D. Bradley* was a self-unloading Great Lakes freighter that sank in a Lake Michigan storm on November 18, 1958. Twenty-three of the thirty-three who died in the sinking hailed from Rogers City, Michigan.

The Bradley was the sister ship of the SS *Cedarville*, sunk in a collision with the Norwegian MV *Topdalsfjord* in a dense fog on May 7, 1965, in the Straits of Mackinac. Experts have concluded the *Bradley* sinking was caused by brittle steel used in its construction in 1927 by the American Shipbuilding Company of Lorain, Ohio.

At 639 feet, *Bradley* was the longest and largest freighter on the Great Lakes for twenty-two years, until 1949, when the *Wilfrid Sykes*, 678 feet, was built. *Bradley* was owned by the Michigan Limestone Division of U.S. Steel and operated by the Bradley Transportation Line.

Some 4,751 Great Lakes shipwrecks have been documented, and as many as 500 are yet to be discovered, according to Eric Jylha, former TV weathercaster and development director of the Bay County Historical Museum. About 61 percent of those ships went down during stormy weather, and most of those storms struck in November. For example, the worst storm was November 7–12, 1913. Some forty ships were destroyed, including eight freighters. The SS *Henry B. Smith*, named for a Ludington lumberman, was one of the boats that went down. It had a crew of 25. No one knows exactly how many died on what became known as "Black Sunday," but at least 235 lives were lost, mostly on Lake Huron.

Besides the *Edmund Fitzgerald*, which went down with twenty-nine souls on the tenth—other November wrecks have taken their toll. The 1940 storm

The SS *Henry B. Smith* went down with a crew of twenty-five during the November 1913 storm. *Courtesy of the Library of Congress.*

The leviathan SS *Edmund Fitzgerald*, sunk on November 10, 1975, in Lake Superior, was the largest ship on the Great Lakes at 729 feet and remains the largest vessel ever sunk on the lakes. Experts are still unsettled about the exact cause of the wreck in eighty-mile-per-hour winds. A Gordon Lightfoot ballad has helped propel the sinking into legend. *Courtesy of the Library of Congress.*

hit on Veterans Day, sinking the *Nodadoc*. There were two deaths. The *Carl D. Bradley* sank on the eighteenth in 1958, and only two of its crew of thirty-five survived. The *Daniel J. Morrell* sank on the twenty-ninth in 1966—twenty-eight died—and one man survived, Dennis Hale.

The *Edmund Fitzgerald* was launched on June 7, 1958, from the Great Lakes Engineering Works at River Rouge, Michigan, a suburb on the south side of Detroit. It was owned by the Northwestern Mutual Life Insurance Company and named after the company's newly elected chairman of the board. The Oglebay-Norton Company of Cleveland, Ohio, chartered the *Fitzgerald* under a long-term contract from Northwestern.

At the time of its launch, the *Fitzgerald* was the largest carrier on the Great Lakes and remained so until 1971. It weighed 13,632 tons and measured 729 feet long by 75 feet wide. Fully loaded, the *Fitzgerald* was capable of carrying 27,500 tons, powered by a 7,500-horsepower steam turbine engine that could move it along at up to sixteen miles per hour (fourteen knots).

In 1964, the *Edmund Fitzgerald* became the first carrier to haul more than one million tons of iron ore pellets (taconite) through the locks at Sault Ste. Marie. That feat earned it the nicknames "Big Fitz" and "Pride of the American Flag." Sailors considered themselves privileged to serve aboard the vessel.

Captain Ernest McSorley—a veteran with over forty years' experience—took command of the *Fitzgerald* for the 1972 shipping season. He had commanded nine ships before the *Fitzgerald*. Captain McSorley, quiet and reserved, was well respected by other captains as a skillful master and by his men, whom he treated as true professionals. Captain McSorley turned sixty-two in 1975 and was happily married. Although they had no children, his wife, Nellie, was the mother of three children from a previous marriage.

The *Fitzgerald* continued its fine record of service under the new captain's command into 1975. However, on October 31, 1975, the U.S. Coast Guard noted a problem during a routine inspection of the vessel at Toledo, Ohio. The inspectors found a number of hatch covers sealing the cargo area would not close properly, meaning that water washed on board the deck would be able to leak into the cargo hold.

Several expeditions have conducted dives on the sunken vessel: the 1989 National Geographic Society/Great Lakes Shipwreck Historical Society expedition, the 1994 McInnis expedition, the 1994 Shannon expedition and the 1995 Michigan State University dive, which recovered the ship's bronze bell. The bell has been restored and is on display at the Great Lakes Shipwreck Museum at Whitefish Point, near the wreck site.

On the twentieth anniversary of the sinking, in its November/December 1995 issue, *Michigan History Magazine* published an interview with noted marine historian Frederick Stonehouse, seeking insight into why the vessel "has been romanticized to the point of legend?" Stonehouse replied,

> *In the public mind, the* Fitzgerald *is an exceptional wreck. It has gone from fact—the unexplained 10 November 1975 loss of a 729 foot freighter with all twenty-nine hands—to become part of the legend of the Great Lakes. It is the blending of historical fact into almost myth. And certainly Gordon Lightfoot's hauntingly beautiful "The Wreck of the Edmund Fitzgerald" has helped push it into legend. It brings home the awful power of nature and the frailness of man and his creations.*

WHEN THE "MAD MALLARD"—LAKE HURON—SWALLOWED SS *CEDARVILLE*

It was May 7, 1965—more than half a century ago.

I was an eager twenty-seven-year-old reporter at the *Bay City Times*.

On May 5, the first large-scale U.S. ground troops entered South Vietnam. It was an ominous sign that would absorb—and tear apart—the nation for the next decade and beyond.

That month, the Beatles' song "Ticket to Ride" hit No. 1 on the pop charts, and Vivian Malone became the first black person to graduate from the University of Alabama.

Things were quiet in Bay City, unless you listened to the men's beards being grown for the sesquicentennial celebration.

Two days later—Friday, May 7—the AP and UPI machines in the glassed-in wire room on the west side of the *Times* newsroom suddenly clacked furiously. Robert Cox, production manager of WTOM-TV in Cheboygan, alerted the world to a breaking story.

"Big news up North," hollered wire editor Wally Town, rushing toward the city desk, burning cigarette in one hand, the other trailing long strips of paper from the Associated Press printer—"two ships collided in the Straits of Mackinac, one cut in half with some crew trapped below," he blurted. "A Norwegian freighter hit the *Cedarville* in heavy fog."

"You better get up there, and take a photographer," said crusty, salty-tongued Ray Kuhn, who had hired me six years before, right after my internship at the *Chicago Tribune*.

Kuhn, managing editor of the *Bay City Times*, arranged for photographer Dick Hardy and me to meet a pilot, Dr. James Cooper, at James Clements Airport. Dr. Cooper was a forty-five-year-old former ace U.S. Air Force pilot and veteran of World War II. A native of Kansas, he was an OB-GYN specialist with an office on Sixteenth Street. His wife, Joan, was his office assistant.

Unable to land any closer because of dense fog enveloping the straits, Dr. Cooper set the four-seat Cessna down gingerly at Pellston, twenty miles east of the straits. We rented a car and arrived at the dock in Mackinaw City on the afternoon of May 7, the day of the accident.

The pea soup fog obscured the huge girders of the five-mile-long Mackinac Bridge—you couldn't even tell it was there, even though its steel superstructure and cables loom 552 feet above the water and stretch five miles from Mackinaw City to St. Ignace.

Foghorns blasted every two minutes—one prolonged blast, plus two short blasts—warning the dozens of ships waiting their chance to safely get under the bridge and into either Lake Michigan or Lake Huron.

Photographer Hardy and I were surprised and saddened to see sobbing women and children on the dock at Mackinaw City. What happened? We soon learned that eight sailors were trapped in the ship below the waters.

We rented a fishing boat with a sliding door for hauling nets, and the captain took us to the spot on the lake where the *Cedarville* had gone down. Only a small orange buoy marking the spot and bubbles in the water—coming from the huge ship below—told the grim tale.

Why had the eight crew members not abandoned ship, boarded the lifeboats or been picked out of the water by other ships? This puzzling situation did not become clear in the inquiry in 1967 and was not fully spelled out until the *Cedarville Conspiracy* by Stephen Cox came out in 2005. *Cedarville* captain Martin Joppich had gotten instructions by radio from U.S. Steel officials in Pittsburgh: don't give up the ship.

The eight men had faithfully stayed at their posts in the engine room and were trapped by the water pouring into the sinking ship through every hold and hull fracture.

The seventeenth-century French explorer Samuel de Champlain called Lake Huron "La Mer Douce," or great sweet-water sea. Huron was the first of the Great Lakes to be discovered and is the second-largest Great Lake and fifth-largest body of freshwater in the world.

Local author Jack Parker wrote about the lake and its nickname "The Mad Mallard": "[T]he lake that swallowed eight big ore carriers in one

René-Robert Cavelier, Sieur de La Salle (1643–1687), was the first European to travel the length of the Mississippi River. He was commandant at Fort Michilimackinac, Detroit and New Orleans. *British Library, public domain.*

storm (November 1913), Huron is rougher, tougher and more violently ferocious than any of our oceans."

Since Huron had more traffic because it is a "pass through" in the chain of lakes, 40 percent of the shipwrecks in the Great Lakes are in Lake Huron, including the *Cedarville*. Since the first ship to disappear in Lake Huron, LaSalle's *Griffon* in 1679, an estimated 6,000 ships have gone down and thirty thousand lives lost. By that measure, Lake Huron has about 2,400 wrecks alone.

Cedarville loaded 14,411 tons of limestone and a crew of thirty-five at Calcite, near Rogers City. The 588-foot-long *Cedarville*, built in 1927 at River Rouge, Michigan, was refitted as a self-unloader at Defoe Shipbuilding in Bay City in 1958. It had been converted from steam to diesel and thus transitioned from SS (steamship) to the designation MV (motor vessel).

Cedarville set sail at 4:30 a.m., heading for U.S. Steel facilities at Gary, Indiana; water temperature was thirty-seven degrees, with choppy seas, thick fog limiting visibility and temperatures in the low forties. Winds from the southwest were light.

The fog worsened as *Cedarville* approached the Mackinac Bridge from the Lake Huron side. The captain was steaming full ahead—12.3 miles per hour—with no concern for the dense fog or other ships known to be in the area. Visibility was limited to three hundred to six hundred feet, about half a mile.

Meanwhile, from the Chicago side, the 424-foot Norwegian freighter *Topdalsfjord*, with Captain Rasmus Haaland in charge, approached the straits, bound for the DeTour passage on the northeast coast, thirty-five miles away. *Topdalsfjord*'s sharp prow raked forward, and its hull was reinforced with thick steel for plowing through North Atlantic ice. The vessel's speed was in excess of six and a half miles per hour, too fast for conditions, an attorney for U.S. Steel later argued at the inquiry.

When the German ship *Weissenburg* passed under Big Mac at 9:38 a.m., the German master told the *Cedarville* captain Martin Joppich that there was a Norwegian vessel ahead. The master of the *Cedarville* tried to make radio contact but could not communicate with the *Topdalsfjord* to arrange for a passing agreement.

After the *Cedarville*'s last long whistle blast, *Topdalsfjord* loomed out of the fog one hundred feet away. Joppich ordered hard right, and then—when the *Cedarville*'s bow passed ahead of the Norwegian—he ordered hard left to try to swing the stern clear.

At 9:45 a.m., *Topdalsfjord*'s sharp prow collided with *Cedarville* abreast of the No. 7 hatch portside at a near perpendicular angle. Many of the crew were unaware there had been a collision.

As the ship rapidly filled with water, Joppich decided to run toward Mackinaw City and attempt to beach the vessel. That's when a bad situation turned tragically wrong.

"The beaching course furnished by the third mate was incorrect and the master should have immediately realized this. It is tragic that the *Cedarville* steamed enough miles following her fatal wound to have made the beach at Mackinaw City," stated the U.S. Coast Guard's Marine Board of Investigation report.

As the Cedarville turned over to starboard, the crew standing by the lifeboats made last minute attempts to launch them. The No. 1 lifeboat was never released and sank with the ship. The No. 2 lifeboat with several crew members aboard was released as the Cedarville sank beneath it. Both life rafts floated free. The majority of the crew were thrown into the cold water.

Twenty-five crew members were rescued by the *Weissenburg*, whose captain and crew were honored by the US. Coast Guard for their lifesaving work.

The inquiry board's report stated: "There is evidence of considerable false optimism on the Cedarville that the vessel would be successful in its beaching operation. Due to this a plan for minimizing personnel in the engine room or abandoning ship was never initiated."

As the sea-laden ship wobbled drunkenly through the water toward shore, it slowly rolled over and sank.

Photographer Hardy and I spent the night in a motel in Mackinaw City, the sound of foghorns haunting our memory for years. The next day, the adventuresome Dr. Cooper flew back and picked us up.

The full story of the *Cedarville* is told in the *Conspiracy* book and dramatized in a video by Out of the Blue Productions, run by noted divers Jim and Pat Stayer, former directors of the Michigan State Underwater Preserve Council.

One of Lake Huron's most popular dive sites, *Cedarville* is part of the Straits of Mackinac Underwater Preserve. It lies in 110 feet of water, and the hull is within 35 feet of the surface. Some artifacts now reside in the new Straits of Mackinac Shipwreck Museum at the Old Mackinac Point lighthouse.

Cedarville goes down in history as the third-worst disaster in Great Lakes history, after the *Edmund Fitzgerald* of 1975 and the *Carl D. Bradley* of 1958.

In a poignant asterisk to the *Cedarville* saga, some of the surviving sailors who died in recent years have had their remains deposited in secure containers near the underwater tombs of their mates aboard the sunken ship.

WHERE IS THE *GRIFFON?*

MYSTERY DISAPPEARANCE NOW OVER THREE CENTURIES OLD

A 330-year-old mystery of what happened to the first shipwreck on the Great Lakes may soon be solved, but only if underwater explorers can resolve their legal problems, mainly, who owns the wreckage and under what terms may it be recovered, if at all.

An old wooden artifact believed to be a bowsprit from *Le Griffon* (a.k.a. *Griffon*) was found in 2001 by Steve Libert's Great Lakes Exploration Group (http://greatlakesexploration.org), but the discovery is the subject of lawsuits involving the underwater explorers, the State of Michigan, the federal government and the government of France. And there is doubt about the authenticity of the artifact, with some observers believing it to be an old fishing net post.

During the winter of 1679, the second ship built on the Great Lakes, *Le Griffon*, was constructed along the Niagara River. *Le Griffon* was built by René-Robert Cavelier, Sieur de La Salle, in his quest to find the Northwest Passage to China and Japan.

"Some museum exhibits and book illustrations also portray the *Griffin* as a large seventeenth-century freighter with three masts and elaborate rigging," the late Dr. George Quimby, a researcher and author who extensively studied histories of the ship, commented. "In reality, La Salle's vessel was a much more modest boat and not at all like the magnificent freighters or men-of-war that usually have been the basis for pictorial reconstructions of the *Griffin*."

While a master carpenter, a blacksmith and about ten other workmen set about building the vessel, hostile Iroquois threatened to burn it. LaSalle's men, warned by a native woman, were forced to guard against the threats, Quimby wrote. The work went on between January 22 and May 27, 1679, when the ship was launched. Dr. Quimby observed: "When one considers that the wood came from trees felled near-by and that the ship's timbers and planking had to be cut and shaped in situ, then fitted into place and fastened, it does not seem possible that so few men could have built a ship of any great size in a period of approximately four months."

Le Griffon was the first full-sized sailing ship on the upper Great Lakes of North America and led the way to modern commercial shipping in that part of the world, according to some authorities. Several smaller vessels were said to have been constructed by LaSalle in an effort to frighten the English, rivals in the fur trade.

The ship was constructed and launched on Cayuga Creek on the Niagara River as a seven-cannon, forty-five-ton barque. La Salle and Father Louis Hennepin set out on the *Le Griffon*'s maiden voyage on August 7, 1679, with a crew of thirty-two, sailing across Lake Erie, Lake Huron and Lake Michigan through uncharted waters that canoes alone had previously explored.

La Salle disembarked, and on September 18, 1679, he sent the ship back toward Niagara with a skeleton crew under command of a sailor named Lucas, also known as "Luke the Dane." On *Le Griffon*'s return trip from Green Bay, Wisconsin, it vanished with all six crew members and a load of furs.

According to Michigan Public Radio, Steve Libert retired as a federal intelligence analyst and moved to Charlevoix a few years ago. Great Lakes Exploration, which has been looking for the *Griffon* for more than thirty years, continues its quest. Libert is steadfast and says he has "no doubt that the architectural timber is that of a ship."

The location where Libert found the ancient wooden artifact in 2001 is consistent with the research of Dr. Quimby in the mid-twentieth century. It's also consistent with Father Hennepin's description of the favorable winds with which *Le Griffon* set sail when it left the Island of the Pottawatomi.

Le Griffon is often mistakenly called the first ship to be lost to the Great Lakes. Actually, the first ship was another built by La Salle, called the *Frontenac*, a ten-ton single-decked brigantine or barque. The *Frontenac* was lost in Lake Ontario on January 8, 1679.

CCC CAMPS DAYS
FONDLY RECALLED BY HALE
CENTENARIAN FRITZ HOLZHEUER

Older Michiganians have fond memories of the Civilian Conservation Corps (CCC) camps of the 1930s, a project that celebrated its eightieth anniversary in 2013.

Widespread events recall the 1930s, when the CCC was one of President Franklin D. Roosevelt's most popular New Deal economic stimulus programs.

In 1932, Roosevelt, as governor of New York, pioneered the CCC concept by putting ten thousand men on public relief in New York to work in reforestation.

From 1933 through 1942, the CCC had more than 3 million young American men working on parks and forests. The program resulted in planting 2.3 billion trees, spent 6.4 million man-days fighting forest fires and did pest control on 21 million acres of land.

In Michigan, 156 million fish were planted; 7,000 miles of truck trails, 504 bridges and 222 buildings were built. The state park system was revitalized, Isle Royale National Park was established and campgrounds were built in national forests.

Dr. Roger Rosentreter, editor of *Michigan History Magazine*, wrote, "Michigan's 102,814 CCC participants—eighth highest among all states—occupied an average of 57 camps annually. Only five states had a higher average. More impressively, Michigan enrollees planted 484 million trees, more than twice as many as any other state."

Frederick W. "Fritz" Holzheuer of Hale recalled working alongside the CCC camp members in the Tawas area in those days. Holzheuer was employed by the U.S. Forest Service planting trees near Lumberman's Monument.

"We had two teams, one digging holes and the other following and planting the little trees," he recalled to a MyBayCity.com reporter. "We had a quota of 100 trees a shift and if we didn't meet it we got yelled at by the foreman." The program instilled discipline as well as work skills that served young Americans well when World War II broke out. *New Republic* magazine dubbed the CCC "Roosevelt's Tree Army."

Holzheuer worked on his father's farm near Hale, graduated from Whittemore High—Hale's only went to the eighth grade—and, as the nation recovered its economic strength, received credit from banks in Standish and Tawas to buy businesses. He first owned a store that is now Kocher's Grocery in Hale. He sold the store and bought Hale Hardware, where he worked until his death on January 13, 2011, at age 101.

Bill Foley Jr., a Grayling area resident, wrote in the *Wilderness Journal* several years ago about tough discipline in the CCC program. Returning late from a weekend walk on the railroad tracks into Grayling to visit his girlfriend Ruth, Foley was found AWOL during a bed check, court-martialed and fined twelve dollars. He received an honorable discharge and moved on to pumping gas for two dollars a day for Ed Gierke, who ran the Hi-Speed station in Grayling.

Later, Foley worked as a survey party chief for the Michigan State Highway Department, traveling every passable road in Crawford and Oscoda Counties in a 1929 Model A Ford two-door sedan, purchased for $60 from Shepard's Ford dealership in Roscommon. He was paid $125 a month, and his WPA (Works Progress Administration) assistants got $60 a month.

FDR's paramilitary jobs program "was created to provide relief and speed recovery from the Great Depression," wrote Dennis Mansfield of Kirtland Community College–Roscommon. The college conducted tours of the site of former CCC Camp Eldorado near the campus last May during Kirtland's Warbler Festival.

The first CCC camps opened in Michigan in the summer of 1933. Men first camped in tents and then in hastily constructed barracks. They planted trees, built firebreaks, fought forest fires and constructed campgrounds. The first camp in Michigan was in the Hiawatha National Forest west of Sault Ste. Marie, established in May 1933, wrote Dr. Rosentreter. A month later, Camp Eldorado, located eleven miles north of Roscommon, was occupied by CCC Company No. 3685. Within months,

there were forty-one similar camps across Northern Michigan with nearly eight thousand members.

CCC workers were paid thirty dollars a month but had to agree to send twenty-two dollars home to support their families. Applicants had to be no shorter than five feet and no taller than six feet, six inches and over 107 pounds. Disqualifying factors included varicose veins, venereal disease and lack of "at least three serviceable natural masticating teeth above and below."

In 1937, education was required for ten hours a week, and classes were offered in subjects ranging from auto mechanics to cooking. Michigan was a leader in developing CCC educational programs, wrote Dr. Rosentreter. Thousands took high school and college correspondence courses through the University of Michigan.

By June 1940, nine hundred eighth grade diplomas had been issued in Michigan alone. Nationally, over 100,000 men were taught to read and write. A poll in 1936 found that 82 percent of Americans supported the CCC. "Three years later another poll listed the corps as the New Deal's third greatest accomplishment....The nation's defense potential was aided by the corps," wrote Rosentreter. "By 1942 many young CCC men had learned how to take orders, the rudiments of sanitation, first aid and personal cleanliness, and other skills directly transferable in time of war."

Still, in 1937, Saginaw's congressman, Republican Fred Crawford, opposed the CCC on the basis that it was too costly and added to the national debt. "I would rather have a boy of mine grow up in private industry and agriculture than in any CCC camp." Other Republicans complained that it was difficult to find farm workers.

Mandatory non-combative military training was made part of CCC education in 1940, as war had broken out in Europe. The onset of war and the improving economy spelled the end of the CCC. "Enrollee desertion had increased and as the economy improved better quality candidates were no longer available or interested in the CCC," commented Dr. Rosentreter.

In June 1942, the U.S. House of Representatives defeated the CCC appropriation despite Roosevelt fighting to keep 150 camps open. New Deal opponents in Congress cited "waste and extravagance" in the CCC and charged it was no longer necessary and that the money spent on the CCC was needed for war supplies. Congress appropriated $8 million to liquidate the agency, and the CCC was dead.

AMERICAN BALD EAGLES

Comeback Species of the Century

Some might call eagles EPA birds. More appropriately they might be termed the "comeback species of the twenty-first century."

Here's why.

From 487 nesting pairs nationwide in 1963 to 750 pairs in Michigan alone now, it's clear bald eagles have made a comeback.

When America adopted the bald eagle as the national symbol in 1782, the country may have had as many as 100,000 nesting eagles. Some estimates range as high as 300,000 to 500,000.

The first major decline of the species probably began in the mid to late 1800s, coinciding with the overall decline of waterfowl, shorebirds and other birds of prey.

The effort to save the eagles actually goes back about seventy-five years. Congress passed the Bald Eagle Protection Act in 1940, as the population was in decline due to indiscriminate killing, habitat destruction and water pollution. That act protects eagles today.

Wildlife experts say the eagles are thriving, finally, after all these years, because of chemical bans and habitat protection. The U.S. Fish and Wildlife Service estimates that there are at least 9,789 nesting pairs of bald eagles in the contiguous United States. Bald eagles have staged a remarkable population rebound and have recovered to the point that they no longer need the protection of the Endangered Species Act.

America's national bird is soaring in numbers in Michigan and finding Northern Michigan among their favorite nesting places, as anyone who notices the wildlife around the area can see.

Distinguished by a white head and white tail feathers, bald eagles are powerful birds that weigh as much as fourteen pounds and have a wingspan of six to eight feet. Male eagles are smaller, weighing as much as ten pounds.

Consumers Energy's eagle habitat plan around its dams and hydro facilities in northeastern Michigan has helped the eagles come back, the company says. Consumers Energy, Michigan's largest utility, is the principal subsidiary of CMS Energy and provides natural gas and electricity to 6.6 million of the state's 10 million residents in all sixty-eight Lower Peninsula counties.

The U.S. Fish and Wildlife Service estimates that in 1963, only 487 nesting pairs of eagles remained in the forty-eight contiguous states. A significant number of the survivors in Michigan were found on inland lakes and hydro reservoirs in the northern lower part of the state and the Upper Peninsula.

Then came waves of public reaction to Rachel Carson's 1962 book, *Silent Spring*, creating a new awareness of the dangers of chemicals in the environment. Legislators quickly jumped to pass new laws banning pesticides, actions unheard of previously.

The book documented the detrimental effects on the environment— particularly on birds—of the widespread use of synthetic pesticides. Carson accused the chemical industry of spreading disinformation and public officials of accepting industry claims unquestioningly.

Silent Spring, a blockbuster roundly criticized by chemical companies and the lobbyists and legislators in their thrall, spurred a new look at national pesticide policy. The nationwide ban on DDT (dichlorodiphenyltrichloroethane) for agricultural uses resulted, but not until ten years after *Silent Spring*'s release.

An environmental movement arose that led to the creation of the U.S. Environmental Protection Agency (EPA). Even today, in some political circles, the EPA is subject to scorn. But the proof that the agency's actions have worked to the benefit of the nation's precious wildlife is in the skies, soaring high and coming down to nest and procreate.

Eagles now are prominent around the mouth of the Saginaw River and in trees along the shore of Saginaw Bay, where even a few years ago it was rare to see one.

Bald eagles nest statewide in Michigan according to Tom Cooley, wildlife pathologist for the Michigan Department of Natural Resources. The birds in Michigan—and in the rest of the nation—were on the brink of extinction in the 1950s and early 1960s, mostly due to chemicals such as PCBs and DDT in pesticides.

The American bald eagle has made an amazing comeback from near extinction from effects of pesticides. *Courtesy of the Library of Congress.*

In the late 1960s, researchers discovered the source of the problem, and chemical bans and species protection laws allowed the bird to slowly make a comeback.

However, eagles still are affected by chemicals, *Scientific American* recently reported. Tests at the University of Michigan have shown that dead eagles have high concentrations of flame retardants in their livers.

Nil Basu, an associate professor at McGill University who led a study while at the University of Michigan, said companies in the 1970s started putting polybrominated diphenyl ethers, PBDEs, into furniture cushions, electronics and clothing in an effort to slow the spread of flames if they catch fire. The chemicals quickly built up in people and the environment. PBDEs have been found in air, dirt and people in virtually every corner of the globe, including the Great Lakes region.

The compounds can leach out of products and persist in the environment. Eagles are exposed through eating contaminated fish, but the chemicals can enter landfills, latch onto dust and be inhaled or be licked off the feathers, said Basu. Starting in the early 2000s, phase-outs of flame retardant PBDEs began.

Conservation really pays off, wildlife experts note. Michigan's eagle population is strong and has been going up, according to Cooley. "We have about 750 active nests throughout the state," he said.

In 2014, beneficial habitats created by Consumers Energy dams have helped bald eagles reach record numbers of breeding pairs in Michigan, the utility reported. "Many of the eagles soaring over Michigan today trace their roots to eagles that nested near Tippy Dam and other hydro facilities Consumers Energy operates along the Manistee, Au Sable and Muskegon Rivers," said Gary Dawson, director of land and water policy at Consumers.

The dams create backwater habitats where eagles can find secluded nesting sites and plenty of fish that are safe for them to eat. The areas around hydro reservoirs provided critical bald eagle refuges when chemicals such as PCB and DDT, banned in the 1970s, severely reduced the eagle population across Michigan and the continental United States. The dams block toxins transported by migrating Great Lakes fish from affecting eagles foraging above the dams.

Eagles feeding above the dams, where fish were up to one hundred times less contaminated than fish below the dams, were able to produce young. A bald eagle's diet is 90 percent fish.

After the chemical bans, eagle offspring that had persisted around hydro facilities were able to spread to other areas of the state and set up breeding territories.

Bald eagles have fledged 270 young around Consumers Energy hydros since 1994, when the company implemented a bald eagle management plan, part of an agreement with regulators to operate river hydro-generating facilities.

"Hydro facilities remain important eagle breeding areas today. While contaminants in fish below the dams have declined substantially over the last two decades, PCB concentrations still exceed EPA's standard for the protection of eagles and other sensitive wildlife," Dawson said. "We are at the midway point in our 40-year bald eagle management plan, and the birds have responded spectacularly."

The 750 bald eagle breeding pairs in Michigan estimated by the U.S. Fish and Wildlife Service is the highest number since their census has been taken, and they are now commonly seen throughout the Great Lakes State.

"The recovery is ongoing," Dawson said. "Michigan will likely see a new record high number of eagles next year."

Bald eagles were removed from the List of Endangered and Threatened Wildlife in 2007.

KIDNAPPING WAS FUTILE ATTEMPT BY VENTURE CAPITALIST TO BAIL OUT PERRY HOTEL

One of the most sensational crimes connected to Northern Michigan involved the effort by a Chicago venture capitalist, Arthur J. Curry, to save the Perry Hotel in Petoskey from bankruptcy.

In 1989, Curry kidnapped the wife of Forbes 400 member Bill Cook, a medical equipment manufacturer. Demanding a ransom of $1.2 million in cash and $500,000 in gold, Curry was captured by the FBI thirty-six hours later. He was convicted in 1990 and sentenced to thirty years in prison.

Rick Coates of the *Northern Express* wrote of the case in 1989:

> *Curry, in the mid to late 1980s, owned both the Perry Hotel in Petoskey and the Park Place Hotel in Traverse City. Both landmarks were on the verge of bankruptcy and Curry's arrival with promises of restoration and economic revitalization were welcome words to business and downtown leaders of the two communities whose economies were ailing.*
>
> *When Curry arrived in Northern Michigan his charisma and flamboyance convinced several local investors in both communities to join him. Using the bait of funds from the Chicago-based brokerage firm he was president of, he collectively raised a couple million dollars for both hotel projects.*
>
> *But as bills didn't get paid and restoration projects at both properties fell behind schedule, Curry became harder to find. He was busy buying an Upper Peninsula ski resort and purchasing a hotel and restaurant in Indiana. Eventually, his brokerage firm forced him out in January of 1989 and he was relieved of his role as operating partner of the hotels.*

The Stafford-Perry Hotel in Petoskey was built in 1899 by Dr. Norman J. Perry as one of some twenty original luxury resort hotels in Michigan at that time. The next owners, also doctors, intended to convert it into a hospital, but town fathers convinced them hotel accommodations were needed. The hotel overlooking Little Traverse Bay is the only one of the twenty still in operation. *Courtesy of the Library of Congress.*

Despite this Curry vowed "to buy the properties outright from the brokerage house and keep the projects on task." His time in Northern Michigan was short-lived as Curry drove both properties further into debt and left several local investors with no return on their investments.

With mounting financial pressures resulting in several failed investment projects, a desperate Curry turned to crime.

Benefiting from good behavior and overcrowding in the prisons, Curry was granted early release the day before Halloween 2001. He has since been re-incarcerated for bank robbery. Once freed from the Cook kidnapping, Curry partnered with his elder brother Daniel. However, business was far from their intent. The two began robbing banks—possibly twenty banks in a three-year period—in southern Indiana and Kentucky.

Currently, Art Curry and his brother are in prison, indicted on four bank robberies that netted over $1 million. Both are serving sentences of up to twenty-five years for bank robbery and up to eighty years for using a weapon for a crime of violence.

Gayle Cook is a 1956 Phi Beta Kappa graduate of Indiana University with a BA in fine arts. In association with her husband, William Cook, Gayle developed their Bloomington-based business, Cook Medical, into one of the world's largest medical device–manufacturing companies.

The hotel has since been acquired by hospitality entrepreneur Stafford Smith of Petoskey and is known as the Stafford-Perry Hotel. Coates tracked down Curry's former wife and published an interview with her in the *Northern Express*, excerpted here:

> *Kristine Curry was often at her husband's side at press conferences and public events in both communities. She oversaw a lot of the day-to-day operations. With their two children, Nathan (Art's son from a previous marriage) and daughter Lindsey (the kids were eight and five respectively when the Curry's bought the Park Place), they appeared to be the all-American family.*
>
> *Mrs. Curry was 39 and had family connections to the area. As a child she summered at the Bayview community in Petoskey and eventually bought her own place there. She grew up in Ida, Michigan (a small community near the Ohio border, south of Detroit) and graduated with a Liberal Arts degree from MSU. She made her way to Chicago and enjoyed a successful marketing career when she met and fell in love with Arthur J. Curry.*
>
> *Eventually, Kristine Curry would become the popular wine and food writer for the* Chicago Tribune *and Arthur climbed his way to the top of the Chicago investment community. The couple was popular around the Chicago social scene.*
>
> *They seemed to have it all. During the purchase of the Perry and Park Place, the couple pledged to live here and be a part of the community. Excitement swirled as this young, dynamic couple brought enthusiasm and inspiration.*
>
> *But both deals soured, and as fast as the Currys arrived in town, they left.*

Coates noted that Kristine Curry has since rebuilt her marketing career; she authored a book about restaurants and writes about wine for several publications. She was charitable in her recollection of her ex-husband: "Art is an extremely brilliant person," said Kristine. "He has so many wonderful qualities—this is such a shame. He really is a remarkable person."

DID REPRESSIVE U.S. INDIAN POLICY, A SAD NORTHERN MICHIGAN LEGACY, INSPIRE HITLER?

American Indian boarding schools that were located at Harbor Springs and Mount Pleasant helped contribute to a legacy of cultural genocide that still haunts the natives of Michigan and repels thinking citizens everywhere.

There were twenty-five federally funded schools across the nation, including the Mount Pleasant Indian School, that enrolled an estimated fifteen thousand Indian students. The Harbor Springs school, Holy Childhood of Jesus Christ Academy (1829–1983), was an anomaly, operated by the Roman Catholic Diocese based in Gaylord.

The first Indian school, Carlisle, in Pennsylvania, began in 1879. Carlisle became famous for its football team starring Jim Thorpe, later an Olympic decathlon champion. Professor Amy Lonetree (Ho Chunk) of the University of California–Santa Cruz produced a twenty-four-page guide to the Indian boarding schools published by the Ziibiwing Center of Anishinabe Culture and Lifeways of the Saginaw Chippewa Tribe of Mount Pleasant.

The concept of Manifest Destiny led American settlers to claim the lands, and even the lives, of Indians, who in fifteen thousand years of their history had established self-governing civilizations that excelled in agriculture and accomplished such advances as use of plants for medicinal purposes. Christian settlers, however, were convinced that the nation was destined to be a strictly Christian civilization. They supported anti-native campaigns such as the Trail of Tears in the southern states, the Black Hawk War in 1832, extermination of western tribes by General George

Armstrong Custer and others, along with Indian schools, whose purpose was to purge native traits, instill European customs and teach English to the children.

By 1900, only 2.5 percent of the original population of Indians survived, noted Professor Lonetree.

In the late 1800s, the federal government began to control native education. "They created assimilation policies that looked to wipe out native languages and culture," wrote Emily Fox for Michigan Public Radio.

Deleta Gasco Smith, of the Little Traverse Bay Band of Odawa, who attended Holy Childhood for three years, recalled, "When we were in the school we were actually completely forbidden to speak the language (Anishinaabemowin) and if we were caught the punishment was swift and it was severe." She recalled that her father was fluent in Anishinaabemowin, but he did not teach it to her because he had gone to the same school and knew she would be beaten for speaking it.

Yvonne Keshick, who attended Holy Childhood for eight years, told Emily Fox: "The darker you were, the worse you were treated." Keshick said she was beaten almost every single day. If she got a math problem wrong, the nun would grab her by the head and use her face to erase the math problems on the chalkboard.

The most startling and repulsive were the effects of national policy calling for "taking the Indian out of the child" that appear to have reverberated to Europe and played a tragic role in Adolf Hitler's rise in Germany. The role of American eugenics, including the Indian boarding schools, may have played a part in the rise of Nazism that resulted in the deaths of some fifty million people in World War II.

The type of eugenics and ethnic cleansing practiced by Hitler actually began in the United States. Indiana and several other states had eugenics

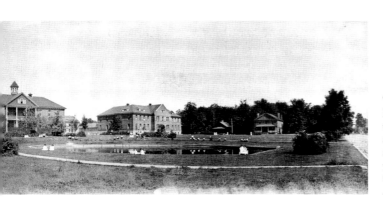

The Mount Pleasant Indian industrial school was one of dozens across the country that aimed to help native youngsters learn useful trades. *Courtesy of the Library of Congress.*

boards that dictated sterilization of "mental defectives," while in Michigan, the state Board of Health was in charge of such actions.

American writer Madison Grant published his book *The Passing of the Great Race* in 1916, advocating killing and sterilizing non-white, non-Christian people to achieve what he considered "racial purity." Grant wrote that his ideal humans were Nordic blonds, the so-called Aryan race so idealized by Hitler. Grant advocated control of the American "Melting Pot" by banning relationships between whites and people of color. He recommended segregating "unfavorable" races in ghettos through public health system "quasi dictatorships."

According to historian John Toland, Hitler "often praised the efficiency [of] America's extermination—by starvation and uneven combat, of the red savages who could not be tamed by captivity." Hitler seems to have had the idea that America's industrial vitality was related to the eugenics policies popular in some states. Hitler wrote Grant a letter about his book, stating: "This is my bible." By 1920, Hitler was advocating removal of the Jewish people from Germany.

Former president Theodore Roosevelt, although hailed as a Progressive, seems to have had a twisted view of race, revealed in his comments to *Scribner's Magazine* in 1917:

> *The book is a capital book, in purpose, in vision, in grasp of the facts our people most need to realize. It shows a fine fearlessness in assailing the popular and mischievous sentimentalities and attractive and corroding falsehood which few men dare assail. It is the work of an American scholar and gentleman, and all Americans should be sincerely grateful to you for writing it.*

Woodworking at the Carlisle Indian School in Pennsylvania. *Courtesy of the Library of Congress.*

Under policies advocated by Dr. John H. Kellogg of Battle Creek (the inventor of corn flakes) and Dr. Victor C. Vaughan, dean of the University of Michigan Medical School, there were at least 3,786 officially documented cases of sterilizations in Michigan from 1913 to 1963. Jeffrey Hodges, in his doctoral dissertation in history at Michigan State University, "Dealing with Degeneracy: Michigan Eugenics in Context" (2001), states that of the 3,786 cases, 74 percent of sterilizations were on females and 26 percent on males; 440 sterilization cases were on people considered mentally ill, while 2,927 were on persons deemed mentally deficient. The remaining 419 were neither—those considered "sexual deviants, epileptics or moral degenerates." Poor families, and nomadic Native Americans, such as the Ottawa, were targeted because they could easily be split up by a county judge, he claimed.

According to a study by the Human Betterment Foundation, founded by Dr. Kellogg, 76 percent of the total sterilizations were performed on the feeble-minded and 73 percent on women. Most of the women suffered from

Above: The Carlisle Indian School in Pennsylvania. *Courtesy of the Library of Congress*.

Right: Dr. John Kellogg (1852–1943), Battle Creek sanitarium director. He was the inventor of Kellogg's Corn Flakes and the cereal firm that bears his name. Dr. Kellogg was an advocate of eugenics, a policy of sterilizing and even executing people considered to be inferior, activities adopted by Nazi leader Adolf Hitler. *Public domain*.

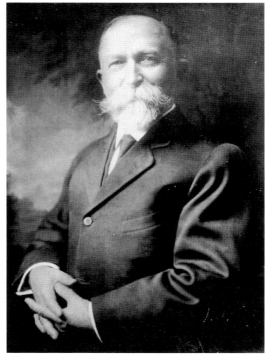

epilepsy, while "many of the men were presumably sex offenders." The foundation aimed to influence the people of Michigan to support positive eugenics programs, encouraging citizens with "beneficial traits" to marry and have large families.

In his master's thesis in 1995, Hodges asserted that medical research in the 1960s proved that many of the defects doctors thought were genetic turned out to be linked to ground and water toxins.

SASSABA, THE INDIAN "COUNT," FLAUNTED BRITISH FLAG

GENERAL CASS STOMPED ON IT

A merica came close to the third war with the British in 1820 during General Lewis Cass's negotiations for the Treaty of Sault Ste. Marie. The American Revolution and the War of 1812 were still fairly fresh memories, and old enmities still rankled the respective combatants, according to historical documents in the Clarke Historical Library, Mount Pleasant.

Cass, superintendent of Indians in the Michigan Territory from 1813 to 1831, aimed to put a fort at the Sault, the connecting link between Lakes Huron and Superior, controlling all trade and limiting British influence in the area. The British, of course, still controlled nearby Canada and remained active in fur trading through the North West Company and Hudson's Bay Company.

When Sassaba, a Chippewa chief called "Count" because of his rank of brigadier general in the British army and service against the United States in the War of 1812, raised the British flag and threatened to kill Cass and his soldiers, Cass tore down the offending banner and stomped on it.

So, what could have been the third war between the United States and Britain, one prosecuted by Indian allies of the Brits, was narrowly avoided.

But Cass was not the real hero of this tale: Jane Johnston (Bamewawagezhikaquay), a half-Chippewa woman and wife of Irish-born fur trader John Johnston, who had been educated in Ireland, calmed the stormy scene that saw both sides threaten to go to war.

Full details of the encounter were included in a doctoral dissertation, "A Survey of Public Opinion as Reported by the Newspapers of the Old

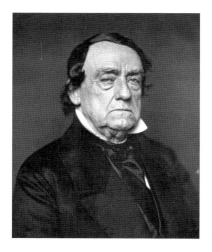

General Lewis Cass (1782–1866), a veteran of the War of 1812, was governor of Michigan Territory from 1813 to 1831 and involved in treaties with Indian tribes very favorable to the United States. In 1848, as a proslavery Democrat, he became the second Michiganian to run for president, after abolitionist James G. Birney, who ran in 1840 and 1844. He was a U.S. senator and served as secretary of state in the Andrew Jackson and James Buchanan cabinets. *Courtesy of the Library of Congress.*

Northwest Territory," by Robert W. Unger at Ball State University, Muncie, Indiana, in 1967.

Cass and his contingent of twenty-six soldiers—in three thirty-foot-long birch bark canoes—set out on May 24, 1820, from Detroit for the straits. Rough water and high winds plagued the journey north, and it took the expedition thirteen days to travel the 360 miles to Mackinac. Henry Rowe Schoolcraft, Indian agent, was a member of the group.

In a week's talks at Mackinac, Cass and his party quickly settled the Treaty of L'Arbre Croche with the Chippewa and Ottawa Indians, who ceded the St. Martin's, or Plaster Islands to the United States. The treaty was signed on July 6, 1820.

Hearing rumors of impending trouble with the Indians at the Sault, Cass expanded his force by adding twenty-five soldiers from Fort Mackinac under command of Lieutenant John S. Pierce. Pierce was the brother of future president Franklin S. Pierce, a Mexican War general who was president from 1853 to 1857.

"Schoolcraft had received reports that the Chippewa at the Sault were hostile and that they were not in any mood to sign a treaty with the United States," wrote Unger.

Although they smoked the peace pipe, opposition by the Chippewa was evident at a council on June 16 called by Cass. The chiefs told interpreter James Riley they did not want an American garrison at the Sault and refused to agree to the cession. Their reasons were evident, Unger observed: "They all were wearing British medals, coats and arms. British influence was quite strong, as Drummond's Island was but forty miles away."

A sculpture of General Lewis Cass in Washington, D.C. *Courtesy of the Library of Congress.*

"Sassaba minced no words; he did not like Americans or the Great White Father at Washington (James Monroe). The Indians would not sell any land, and if Cass and his party did not leave, they would all be killed." The angry Count drove his war lance into the ground at Cass's feet and, kicking aside the presents, marched out of the lodge. The rest of the Indians followed, and a showdown seemed imminent. The Americans made preparation for an attack.

The Ottawa

Michigan treaties. *Between 1795 and 1836, treaties with the United States government opened Michigan to American settlement and restricted its Indian population to a few special reservations.*

U.S. government treaties with Indian tribes covered the entire state and opened millions of acres for settlers for pennies an acre. *Courtesy of Michigan State University.*

Cass was informed the Indians had raised a British flag in their camp. "This was a supreme act of defiance; prompt action was necessary. Along with Riley, the interpreter, Cass hastened to the Indian camp, pulled down the British flag, and stomped on it. Then he went to Sassaba's lodge and threatened to crush the Indians if they attempted to raise another British flag, making it clear [that] two flags, tokens of national sovereignty, could not fly over the same soil in peace."

Unger observed: "Cass's bold action astounded the Indians and impressed them with his courage and forthrightness. Both sides made preparations for battle, each expecting the other to attack."

Mrs. Johnson had her son gather the leading moderate chiefs, Sassaba having departed, for a council at her home. "She told them that if a shot were fired, the whole tribe would suffer." The Americans surely would attack, she said, hinting that the British would not support them.

At another council at the Johnson home, the chiefs apologized for Sassaba's behavior. Unger concluded: "In this attitude of conciliation, the Treaty of Sault de St. Marie was quickly arranged and signed June 16, 1820. By its terms the Chippewa ceded sixteen square miles of land in return for perpetual fishing rights at the Sault. The United States now had its land for a fort and could begin to control the area."

Cass always gave Mrs. Johnson full credit for her part in the treaty, although some historians, including Schoolcraft, failed to mention her.

EPIC GAYLORD GAS WELL EXPLOSION SNUFFED BY TEXAS FIREFIGHTER "RED" ADAIR

A natural gas well explosion near Gaylord in March 1970 commanded the attention of two of the world's top firefighters, Red Adair and Ed "Coots" Matthews, but the well blazed for nearly two weeks until their special mudpack treatment pumped into the ground snuffed it out.

Headlines around the world screamed as the man versus nature blaze roared "like a freight train passing close," commented Clark Bates, captain of Gaylord's volunteer firefighters, whose three rigs couldn't get close enough to get even a small stream of water on it. "It is just a big ball of flame out there," Bates added. "We couldn't get within 300 yards of it."

The well, presumed dry until drilling hit 5,953 feet in depth, was part of the Otsego County "Golden Belt," a crescent-shaped field below which riches were found in a formation called "the Niagaran pinnacle reef," which exceeded the dreams of petroleum prospectors and investors. "Manistee, Mason, Cheboygan and Alpena counties quickly joined Grand Traverse, Kalkaska, Otsego and Presque Isle counties as places where pinnacle reef successes were reported," according to *Michigan Oil & Gas News*, the industry newsletter.

Adair, who died aged eighty-nine in 2004, was "a swashbuckling 20th-century hero, portrayed fittingly on screen by John Wayne, and he probably did more than any other person single-handedly to preserve the environment," wrote the *Guardian*.

> *The fires he extinguished were so enormous that they threatened to be dangerous contributors to global warming, or the potential causes of intercontinental air pollution disasters.*

His greatest feat came when he was in his seventies—confronting 117 gigantic oil-well infernos that dominated the horizon in Kuwait, the legacy of Saddam Hussein's departing Iraqi troops after the first Gulf war. Adair and his crews finished putting out the fires in nine months, as opposed to the five years first envisaged, without a single casualty, and indeed the 5-foot-7-inch boss maintained that none of his employees had ever suffered a serious injury while firefighting.

Jim Grisso, a former *Otsego County Herald-Times* publisher, recalled the Gaylord blaze:

It was, and probably still is, the worst gas well fire on record in Northern Michigan: you could see the sky lit up from the Mackinac Bridge; it burned 3,000 pounds per square inch from 6,000 feet beneath the surface; resulted in a $120,000 burn-off of natural gas; cost $50,000 employing gas well firefighting professionals to extinguish; and had its last flicker March 15, 12 days after it ignited.

The blaze started at 1:00 a.m. on Tuesday, March 3, 1970, at the drilling site when a valve below the surface burst while workmen were bleeding a two-inch, high-pressure line. Robert Hubbard Jr., thirty-two, of Evart, one of four Hubbard brothers on the rig, was struck in the jaw by a pipe and also suffered second- and third-degree burns over much of his body. Two of his brothers, twenty-eight-year-old Barry and twenty-five-year-old David, were injured, treated for facial burns at Otsego Community Hospital in Gaylord and released.

Otsego County and Charlton Township firefighters arrived at the scene but were turned back by drilling company officials who contacted Adair, who arrived that evening on a plane from Dallas.

Adair and Matthews used a heavy mud mixture in the pipe to shut off the gas flow and extinguish the fire. An estimated five hundred bags of mud were used in the snuffing operation.

While drilling was being done by the North American Drilling Company of Mt. Pleasant, the well was owned by Murell Welch and investors of the Shell Oil. Co. State-Chester 1-15 Joint Venture Co., also of Mt. Pleasant. Welch estimated the well could produce twenty-five million cubic feet of gas per day and the loss at $500 per hour.

Water to cool the site was drawn through five-inch piping laid about a mile and a half to the North Branch of the AuSable River.

Above: Famed Texas firefighter Red Adair (*right*) directs crew at the Gaylord gas well fire in 1970. Otsego County Herald-Times, *Clarke Historical Library*.

Left: The Gaylord gas well fire of 1970. Otsego County Herald-Times, *Clarke Historical Library*.

Despite the dangers, no damage was caused to the environment, as the blaze was confined to the immediate area of the well, according to the Michigan Department of Natural Resources. The site was surrounded by swamp. DNR district forester Jerry Lawrence said: "As long as this has to happen, this is a good area for it to happen. There are no valuable trees in danger."

In 1976, *Bay City Times* reporter Karl D. Albrecht returned to the Gaylord fire site to check on the environmental status. "At least in the rich oil area centering around Otsego County, serious or permanent damage to the environment is practically non-existent in and around present and past sites." Referencing the 1970 gas well blowout, he wrote: "Despite the intensity of this fire only a few acres were damaged—mostly by firefighting and cleanup crew machinery," he reported.

The rule of thumb for drilling operations is "don't do any damage that next year's greening won't take care of" said Sid Dyer, chief geologist for the DNR Region II, adding, "In most cases, within a few years and very often within months or even weeks, you can't tell where a well was drilled."

While this gas well fire reportedly was the first in Northern Michigan, the state's first such mishap was in 1959 in Hillsdale County, where an entire field of wells was ignited. That fire was covered by this author, then a college journalism student for NBC News, Chicago.

ABUNDANCE OF FOSSILS
IN ALPENA LIMESTONE QUARRY
NEW TOURISM DRAW

A geological wonderland formed 350 million years ago near Alpena is developing into one of Northern Michigan's most visited sites. Why?

Fossils have been found in almost endless varieties in the Lafarge limestone quarry, where digging for the past 110 years has uncovered millions of tons of rock for cement and the fossils, which fascinate many people—at least those who lean toward paleontology as a hobby.

One tour guide, known as Paleo Joe, a.k.a. Joseph Kchodl, of Midland, has a thriving business taking groups to the quarry, where they can discover the ancient remains of creatures like trilobites, crinoids and hexagonaria, a type of coral that, after extensive shaping and polishing ends up as the sought-after Petoskey stone. The tortured alphabet soup of other creatures includes athyris, mucrospirifer, strophodonta, crytina, trachypora, aulocystis.

Kchodl explained that Michigan was once—during the Middle Devonian period—at the bottom of a shallow saltwater tropical sea, proven by the fact that corals found in the quarry are warm-water creatures. Amazingly, the area comprising the state was located near the equator at that time but was moved north by the action of plate tectonics.

"In another 350 million years, we could be up somewhere by Alaska," he told the *Midland Daily News*. The one-hundred-foot high quarry walls are like a time capsule, different layers having been formed over the ages by hurricanes that threw up sand, killing the coral reefs over and over. Kchodl

from a nation wholly unready to dispense with the evil practice at that point in history.

The Clarke Historical Library at Central Michigan University had a recent exhibit featuring the grayling and other notable Michigan fish based on the research and hobby of Dr. Robert Kohrman, former dean of the College of Science and Technology at CMU. Kohrman is an avid angler and writer on the subject of sport fishing.

"Dr. Kohrman shares two things in common with the early writers of American angling books: a love of the sport of fly fishing and a love of the literature that has grown up around it," said Clarke librarian John Fierst in introducing Kohrman at the opening of the exhibit at the Clarke Library.

"A grayling, fresh from the ice-cold water, is a delicate, almost exotic fish," wrote Darryl Quidort in a *Fish Alaska Magazine* article titled "In Search of the Holy Grayling." A Michigan native, Quidort writes reverently, almost breathlessly, about his pursuit of the grayling in Alaska—grayling have been extinct in Michigan for many years.

However, Quidort became one of the rare fishermen to have caught a grayling in Michigan in the 1980s, when attempts were being made by fish culturists to bring the species back to the AuSable River:

> *Their great sail-like dorsal fin, fine black spots and iridescent purple or bluish sheen gives them a rare beauty. In areas where they are abundant, it's hard to believe they are a fragile fish. But they can be just as fragile as the pristine wilderness they live in. Grayling are so precious that they are measured in inches, not pounds like other, coarser fish.*

Dr. Kohrman wrote two articles for *American Fly Fishing*, the journal of the American Museum of Fly Fishing, in 2012, titled "In Search of the Michigan Grayling, Part 1: Daniel H. Fitzhugh Jr., the Father of Grayling Fishing," and "In Search of the Michigan Grayling, Part 2: Thaddeus Norris and the AuSable River Boat."

Fitzhugh came to Bay City in 1847 and built a large house at Third and Water Streets. After a few years, he departed for New York, where he was a stockbroker. His love of fishing and the outdoors soon brought him back to Bay City. Later, he built an imposing mansion at 914 Center Avenue.

Augustus Gansser recalled in his 1905 *History of Bay County*, "Mr. Fitzhugh was the first to discover the habits and cause to be properly classified the fish known as the grayling, which are abundant in the waters

of the northern portion of our peninsula. In after years those who have in any way been instrumental in promoting the interests of fish culture will be looked upon as benefactors of the human race."

In 1873, Fitzhugh asked the Michigan House of Representatives for legislation to protect the grayling and the brook trout. He reportedly sent several samples of the fish to the Smithsonian Museum in Washington, D.C., and was leading efforts to protect and allow it to thrive.

However, another version of the tale of the emergence of the grayling has surfaced. In 1902, Fred Mather wrote a piece titled "My Angling Friends" about Fitzhugh:

> *He was credited with being the discoverer of the fish in Michigan waters, but this he properly disclaimed; he merely sent some species to New York City, where they were the subject of a hot debate among the English anglers and epicures who frequented Sutherlands Café, where the fish was shown and served in 1872. He wrote to a New York journal that Dr. J.C. Parker, of Grand Rapids, Mich., had classified the fish some five years before in a letter to the late Prof. E.D. Cope, of Philadelphia, to whom he sent specimens, and correctly diagnosed them as a true grayling.*

Professor James W. Milner commented:

> *This beautiful little game fish, of the family of salmons, is only found in a few rivers of your State, and the head waters of the Yellowstone river. It would be a great pity to have it exterminated, as it will be if not protected, as it is not nearly as numerous as its relatives, the brook trout. A species of the same genus,* Thymallus volgaris, *of Europe, is a spring spawner, and spawns in the month of April. The same period will, undoubtedly, be found to be the habit of the Michigan species, and in this month, it should be protected from capture.*

However, by that time overfishing and the depredations of lumbering had reduced the grayling population and its habitat and the fish soon died out here. "The loggers were responsible for the loss of the grayling," said Michigan's first conservation officer, Rube Babbitt Jr., in a 1929 interview with the *Detroit News*.

> *When the pines went, the streams became impure through erosion. Soil was washed into them by the rains, and the grayling could not*

live in muddy, dirty water. No longer shaded by trees, the rivers rose in temperature—another important factor, as the grayling needed water almost as cold as ice. The grayling is gone forever—gone with the pines and the pigeons and the Michigan that used to be.

Several efforts to reestablish the species have not been successful, although the arctic species of grayling has been planted and is thriving in some lakes in the state.

Daniel Fitzhugh died on June 26, 1896. Herschel Whitaker, president of the Michigan Fish Commission, offered this tribute at the funeral: "He was one of nature's noblemen, a true sportsman, a brave spirit, with a heart as gentle as a woman's."

DURANT CASTLE SITE
ON THE AUSABLE SO POPULAR
SHERIFF POSTS MAP

Nothing remains but rubble of the 1920s site of a magnificent castle built along the AuSable River by the son of General Motors pioneer William Durant.

Nonetheless, the site is so much an attraction that the Crawford County sheriff saw fit to post directions and a map online. Like other haunted sites, the aura of Durant Castle is created by the tales that emanate from it, growing with each telling.

One such forest legend is that the workmen on the castle were coming into Grayling, Roscommon and other nearby towns and sporting around with the local rustic maidens, angering the local men, who were resentful of the attention to their women.

That story is contradicted by Durant's biography:

> *During the late 1920s Durant's son, Russell Clifford (Cliff) Durant and his third wife, Lea Gapsky Durant, started construction on a personal castle and private airstrip in Roscommon, Michigan, along the south branch of the Au Sable River. The fifty-four-room mansion burned to the ground under mysterious circumstances on February 6, 1931. The Durants never inhabited it. Arson was suspected, allegedly at the hands of trade unionists, whom Durant had refused to recognize.*

Examination of the ruins revealed evidence of arson: the fire started at both ends of the building.

Noted outdoor adventure writer James Oliver Curwood, an Owosso native, shows off 15¾ pound northern pike caught at Mounds Resort in Houghton Lake, 1923. *Courtesy of Dr. Randall Brown.*

Cliff Durant married Lena Pearl McFarland, then wed singing star Adelaide Pearl Frost in 1911. Adelaide later married noted auto racer Eddie Rickenbacker. Lea Gapsky was followed by Charlotte Phillips. A well-known playboy as well as an auto racer, the wealthy Durant was co-owner, with Cecil B. DeMille, of the Beverly Hills Speedway, which was located on today's site of the Beverly Wilshire Hotel.

Randall Brown, a retired dentist from Bay City, who owns the former James Oliver Curwood cabin nearby on the South Branch of the AuSable, said neighborhood lore is that the Durant Castle had elaborate murals painted throughout the home and copious ornate furnishings following the rustic theme. Also, Cliff Durant supposedly had numerous Cadillac autos on the site that he used for local transportation.

All that remains of the castle and private airstrip are the old foundation works. Today, a canoe landing and short history of the castle are on the site. Nevertheless, its storied history is a magnet for visitors to the Grayling area of Northern Michigan.

CHARLTON HESTON, A.K.A. MOSES, FONDLY RECALLED NORTHERN MICHIGAN BOYHOOD

Famed actor Charlton Heston had roots in Northern Michigan, where he learned to appreciate the out-of-doors and the manly pursuit of game animals with firearms.

Heston was born John Charles Carter in No Man's Land, an unincorporated area between Evanston and Wilmette, Illinois, in 1923. The son of Lilla Charlton and Russell Whitford Carter, a lumber mill operator and real estate developer from St. Helen, Michigan, Heston was of English and Scottish descent and claimed membership in the Fraser clan.

"Although Heston spent most of his life in Hollywood and its environs, the actor always thought of himself as a boy from Up North," wrote John J. Miller for the MyNorth blog of *Traverse Magazine* in 2012. Heston wrote in his 2000 book, *The Courage to Be Free*, "[T]he Northern Michigan of my boyhood is still in my blood. Where else but in America could a lanky country kid named Charlton sprout in the anonymity of the Michigan Northwoods and forge a life that makes a difference."

His early life in St. Helen, a Roscommon County former lumbering town, was in no sense a pinched existence. The family lived in what was known as the Carter Mansion. However, he attended a one-room school with only thirteen students. His son, Fraser, a Hollywood filmmaker, noted, "He came from an outdoor tradition, knowing how to use firearms, paddle canoes and wield axes." The senior Heston recalled sledding on the hill in St. Helen, walking through the woods and shooting

rabbits with a .22 rifle. "Hunting is one of the most beneficial means of helping a boy make a transition to responsible manhood," he wrote in his autobiography.

Much like Ernest Hemingway a generation before, Charlton Heston came to personify life in the Michigan woods. Deer became a family staple when money was short. He would return to the north periodically and hung on to his family's 1,300 acres in the woods, which included a small lodge at Russell Lake. Every Christmas, the caretaker would ship a pine tree by train to him for the holiday in California, another poignant link to his childhood.

"An idyllic childhood spent hunting and fishing in the St. Helen woods of Michigan ended abruptly at age 10 when his city-bred mother left his blue-collar father for life in Chicago with another man," wrote Douglass K. Daniel for the Associated Press in February 2017.

> *A new name came with the move, but young Chuck Heston always thought of himself as a hick kid.*
>
> *Acting in high school plays was a good fit for the deep-voiced, 6-foot-3 teenager. He met Lydia Clarke while they studied drama at Northwestern University, marrying her before he went off to serve as a gunner on B-25 combat missions during World War II. Reunited in 1946, they headed for New York. Heston made a stronger impression in live television dramas than the stage and by 1950 had attracted the attention of moviemakers.*

He appeared in more than one hundred films in a sixty-year acting career and is best known for roles as Moses, in Cecil B. DeMille's *The Ten Commandments*, in the title role of *Ben-Hur* and as Michelangelo in *The Agony and the Ecstasy*.

In 2008, Glenn Schicker wrote of Heston's boyhood in the *Houghton Lake Resorter*:

> *In her 1976 booklet, "The Heritage of Richfield Township," St. Helen history buff Peggy Diss wrote that in an interview with Heston, he had "memories of romping over the barren sandy fields with his dog." He played pirates among the maze of rice fields in Lake St. Helen.*
>
> *He spent hours watching the men and big teams pull in the big ice blocks for the ice house. He remembers sliding down Madison Street on a sled.... He remembers the stories his father read to him, and he recalls how he used to use the woods and trees to help him act out those stories.*

At age five, the future Academy Award winner was given a part in a Christmas play at the St. Helen School. "Since it was a one-room school with an enrollment of 13, landing the role was hardly due to unusual talent on my part," Heston told Diss.

Heston spent much of his boyhood growing up in St. Helen and the Houghton Lake area, trimming Christmas trees on the extensive family forest property. It was during this period that he came to Bay City, staying in the Wenonah Hotel with his father, who was there on business. His mother and Russell Carter divorced when the boy was ten. She married Chester Heston, a factory superintendent, and the family lived in Wilmette, Illinois, a northern suburb of Chicago, where Heston attended the elite New Trier High School.

New Trier's active drama program attracted young Heston, and his first acting was in the silent 16-mm amateur film adaptation of *Peer Gynt* by classmate David Bradley, who later became a filmmaker. Heston's acting roles in the Winnetka Community Theatre earned him a drama scholarship to Northwestern University in Evanston, Illinois.

After the Wenonah Hotel fire in Bay City on December 10, 1977, the mosaic of Princess Wenonah—the mother of Hiawatha in the Longfellow poem of that name—that had graced the lobby was salvaged from the burned wreckage. It languished, mud-spattered, in a farm field.

A photo and news story about the mosaic found its way to Hollywood and to Heston, at that time a fifty-four-year-old actor at the peak of screen fame.

Heston sent a check for $100 to preserve the Princess. In a letter, the actor related how he had fond memories of seeing the mosaic of Princess Wenonah on many trips from his home in St. Helen with his parents, who often stayed at the Wenonah.

The check with the great man's signature ended up on my desk at the *Bay City Times* and was turned over to the business manager for safekeeping. The donation check was returned by the manager of the *Times*, Rex Thatcher, since there was no official organization formed to handle the money.

However, the fact that Heston was interested in the mosaic inspired others, and finally, the Princess was preserved through the efforts of historians. It was on display on the ground floor at Bay City's city hall for many years and has been donated to the Bay County Historical Museum.

While he was a film star, Heston would occasionally visit Bay City and come to the newspaper to see his cousin, Marshall Carter, the longtime advertising manager.

In 1982, Heston gave a lecture at Delta College, a community college near Bay City, and had dinner with college officials before returning to Hollywood. Hal Arman, then assistant to Delta president Donald J. Carlyon, recalled that Heston said, "just call me Chuck," and college officials found the actor humble and given to self-deprecating humor.

Carlyon recalled his wife, Betty, riding to and from a dinner at the Bay Valley Resort in a limo with Heston and enjoying chatting with the film celebrity.

In his lecture, which was offered free by the college, Heston talked about his acting career, observing that all his leading ladies had bad breath because filming went on for ten- to twelve-hour stretches without break, giving them no chance to freshen up.

As he departed for the airport to return to Hollywood, Heston graciously signed autographs and favored an adventuresome female fan with a kiss on the cheek. "If you're ever out in California, stop in and I'll buy dinner," Arman recalled Heston saying.

The name Heston was vaulted back in Michigan news in recent years when Jerry Nunn of the *Bay City Times* wrote that the state wanted to purchase about 1,300 acres of Heston's property near Lake St. Helen in Roscommon County. His extensive Roscommon County property was acquired by the State of Michigan for land conservation.

Heston's relationship with guns was part of his military career as a gunner on B-25s during World War II, but most of all, he is recalled holding aloft an antique rifle after his reelection on May 20, 2000, as president of the National Rifle Association during a stirring soliloquy defending the Second Amendment right to bear arms:

Every time our country stands in the path of danger, an instinct seems to summon her finest first. When freedom shines in the face of true peril, it's always the patriots who first hear the call.

When loss of liberty looms, as it does now, the siren sounds first in the hearts of freedom's vanguard. Like smoke in the air of our Concord bridges and Pearl Harbors, it's always smelled first by the farmers who come from their simple homes to find the fire and fight. Because they know that sacred stuff resides in that wooden stock and blued steel. Something that gives the most common man the most uncommon of freedoms.

When ordinary hands can possess the most extraordinary instrument that symbolizes the full measure of human dignity and liberty. That's why these five words issue an irresistible call to us all, and we must.

So...[handed antique Revolutionary War–era long rifle] *as we set out this year to defeat the divisive force that would take freedom away, I want to say those fighting words for everyone within the sound of my voice, to hear and to heed, and especially for you Mr. Gore* [Senator Al Gore, advocate of gun control] [holds gun aloft]...*from my cold dead hands...*

Although better known as a conservative, in his early years, Heston campaigned for Adlai Stevenson in 1956 and John F. Kennedy in 1960. In the 1980s, he did a turnaround and supported conservative and libertarian causes and campaigned for Ronald Reagan, George H.W. Bush and George W. Bush. Although he was a supporter of gun control in 1968, he later backed conservative causes and candidates and headed the National Rifle Association for five years. In 2003, he received the Presidential Medal of Freedom from George W. Bush.

A few presidential elections ago, bumper stickers sprang up that read "My President is Charlton Heston," indicating his popularity for supporting the right to bear arms.

Heston volunteered in the civil rights movement in the 1960s and even marched alongside the Reverend Dr. Martin Luther King in several protest demonstrations, including the 1963 March on Washington. In the original uncut version of *King: A Filmed Record, Montgomery to Memphis* (1970), Heston appears as narrator.

He saw no contradiction between his civil rights work in the 1960s and advocacy of gun ownership rights in the 1990s and beyond, saying in both areas he was "promoting freedom in the truest sense."

According to his autobiography, *In the Arena*, he supported the freedom of speech and the First Amendment. He opposed McCarthyism, racial segregation and the Vietnam War and considered Richard Nixon a disaster for America. He contended that he was a Native American and decried protests against use of native nicknames in sports.

He clashed with Chinese officials while directing a stage production in Beijing in 1988, insisting that his actors be paid a fair wage. He took the same stand with several American directors.

Heston gave one of the most memorable speeches ever written and presented by an actor. His peroration, "Winning the Cultural War," was given on February 16, 1999, at Harvard University Law School:

"If Americans believed in political correctness, we'd still be King George's boys—subjects bound to the British crown," he said.

127

"Firearms are not the only issue.…I've come to understand that a cultural war is raging across our land in which, with Orwellian fervor, certain accepted thoughts and speech are mandated."

He urged the Harvard law students: "Follow in the hallowed footsteps of the great disobediences of history that freed exiles, founded religions, defeated tyrants, and, yes, in the hands of an aroused rabble in arms and a few great men, by God's grace, built this country. If Dr. King were here, I think he would agree."

Fraser Clarke Heston spoke of his father's love for tennis, which he played every Sunday with friends. Heston once played in a charity fundraising tennis event in Bloomfield Hills, Michigan, in the 1980s.

Heston served in the U.S. Army Air Force in 1944–45 as a B-25 radio operator and gunner stationed in the Alaskan Aleutian Islands with the Eleventh Air Force, rising to the rank of staff sergeant. Heston married Northwestern student Lydia Marie Clarke in 1944.

The 1959 title role in *Ben-Hur*, turned down by Marlon Brando, Burt Lancaster and Rock Hudson, won Heston the Academy Award for Best Actor, one of eleven Oscars won by the film. Heston had leading roles in epic films *El Cid* (1961), *55 Days at Peking* (1963), *The Agony and the Ecstasy* (1965) and *Khartoum* (1966).

In 2002, Heston became aware of the onset of symptoms of Alzheimer's disease and announced his retirement from public life with a letter addressed to friends, colleagues and fans:

> *I'm grateful that I was born in America, that cradle of freedom and opportunity, where a kid from the Michigan Northwoods can work hard and make something of his life. I'm grateful for the gift of the greatest words ever written, that let me share with you the infinite scope of the human experience. As an actor, I'm thankful that I've lived not one life, but many.*

Actor Charlton Heston died on April 5, 2008, at age eighty-four—following a battle with Alzheimer's disease—in his Beverly Hills home. About three hundred persons, including Nancy Reagan and Governor Arnold Schwarzenegger, attended the funeral service at the Episcopal Parish of St. Matthews in Pacific Palisades. Heston's son talked about his father's devotion to America and said he "loved his country."

Walker studied chemical engineering at Michigan Technological University–Houghton, worked for a time in high school at the Dow Chemical Company and earned a bachelor of arts in theatre and drama at the University of Michigan–Ann Arbor. She also lived for a time in Paris "because I wanted to sit where Hemingway sat. I feel a kinship to Hemingway as he had formed a kinship with my people on my land in his time."

Walker worked in New York City for an advertising agency that handled all the major Broadway plays. She spring-boarded her acting career when she moved to Hollywood but put that career on hold to make good on a promise made to her mother. After her mother died, Kateri often returned to Midland and cared for her ailing father. After their deaths, she moved back to Hollywood and restarted her film career, for which she has already received many awards. She has starred in the daytime soap *As the World Turns* and has appeared in several movies, including *The Scarlet Letter*, *Renegade*, *Missionary Man* and *Kissed by Lightning*, for which she was nominated for Best Female Performance by ACTRA (the Canadian Union for performers). She also is a member of native voices at the Autry, where actors help writers develop their craft. It's another way to have her voice heard.

French cult-film director Jan Kounen cast Kateri in a role written expressly for her in the Ayahuasca (healing spirit medicine) feature film *Blueberry* (called *Renegade* in the United States). Walker also helped Kounen executives produce *Vape Wave*, a 2017 documentary about the debasement of sacred tobacco through "vaping" with electronic cigarettes. The film's focus is to raise awareness of the harmful, addictive and deadly qualities of cigarettes and, most importantly, the abuse of sacred plants, especially tobacco: "We use it to give respect as an offering for information from plants and show respect to people."

Kateri is also a Jingle Dress dancer and offers all of her performances in respect for her parents, Mary Anne DeLeary and James R. Walker.

IDLEWILD

MICHIGAN'S ONLY NEGRO GHOST TOWN
CREATED BY CIVIL RIGHTS PROGRESS

I dlewild, "the only Negro ghost town in Michigan history," once America's largest resort for blacks, now is a virtually abandoned wasteland but one with glorious memories.

Called the "Black Eden," Idlewild has a half-century history of drawing crowds of eager people on weekends and holidays and featuring stars such as Sarah Vaughn, Dinah Washington and Louis Armstrong and big bands performing at the Flamingo and Paradise clubs.

Growth of the black middle class with money to spend and almost nowhere to go led some to drive hundreds of miles from steamy Midwest cities like Detroit, Chicago, Cleveland, Flint and Saginaw to spend part of their summers in a black haven in cool Northern Michigan.

A hotbed of activity from its start in 1915, Idlewild rocked until it began dying after passage of civil rights legislation in the 1960s and African Americans had many more options for accommodations and recreation. The Fourth of July 1959 may have been the high point; an estimated twenty-five thousand jammed the clubhouse skating rink and thronged the barbeque stands, hotels and nightclubs. A joke was circulated, playing off the name, that it was a place for "idle men" and "wild women."

It all started when the Idlewild Resort Company of Chicago founded the resort on 2,700 acres surrounding Lake Idlewild near Baldwin, Lake County, in northwest Michigan. The company's ads, placed in big city newspapers, sketched images of paradise: "Beautiful lakes of pure spring

water, teeming with fish; high and dry building sites; game of all kinds roaming the green forests; and the promise of tennis courts, golf links and a ball park." Of course, those amenities never came, but the people poured out of the cities and motored to Northern Michigan to find a place where they were welcome and could enjoy the scenery with friends.

The Chicago promoters were right on: Lake County is half public land, with 200,000 acres of forests beckoning tourists. It lives up to its name with 156 lakes and 46 trout streams snaking about 1,000 miles within county boundaries. The largest city and the county seat is Baldwin, with about 1,200 residents, about a third of them black or Native American. The Manistee National Forest and the Pere Marquette State Forest have scattered groves of fir and deciduous trees looming nearby as in days of yore. There is even a crossroads appropriately called Nirvana, the name taken from Buddhists who asserted it to be a state of perfect quietude, freedom and highest happiness. If you seek such a state of bliss, Nirvana is on east US-10 in Cherry Valley Township.

The years 1927–29 were high times at Idlewild. In addition to tent campers, about two thousand cottages and homes were built at Idlewild. On weekends and holidays, auto license plates from many states in the union were seen at the resort. A post office established during the heyday at 812 East Essex Street has served the community for many years, despite its decline. Today, only a church, the First Baptist Church of Idlewild, at 7552 Forman Road, remains viable, but it is surrounded by dozens of shuttered stores, run-down buildings and unoccupied homes in a ten-square-mile area. Those residents remaining are mainly poor, drawing comment from a local official: "The tragedy is that this impoverishment has already existed for more than a generation."

In 1966, the *Grand Rapids Press* observed that, with the lowering of racial bars, African Americans began forsaking Idlewild for the white places from which they had previously been forbidden. The newspaper commented, "And now Idlewild is down at the heels. Streets run through the woods to nowhere. Reeds grow in muddy waters where thousands of Negroes once swam; the stands where vendors once hawked ribs are boarded up. Gone, all gone, the boardwalks, the lights, the jazz and the noise."

Author Roy L. Dodge visited Idlewild in 1970 and spoke to a smiling, white-haired seventy-four-year-old man who had moved there from Detroit when he retired. Asked whether the town would ever boom again, the man, gazing dreamily, suddenly brightened and exclaimed, "She shore will! She shore will!…Why, when the Fourth of July comes

again this year you won't be able to walk down the street it'll be so jammed with folks!" The phrase "hope springs eternal in the human heart" comes to mind. Hope lives in Idlewild; in 2000, the Lake County African American Chamber of Commerce was founded to promote renewed growth in the moribund area.

BEAR WHISPERER

SPIKEHORN WON BATTLES
AGAINST CONSERVATION OFFICERS

One of Northern Michigan's most legendary characters was John E. "Spikehorn" Meyer, whose bear den at US-27 and M-61 near Harrison was a tourist attraction from the 1930s until the mid-1950s. Dressed in fringed buckskin and sporting a hirsute mane of white hair and a beard, he was the main attraction one newspaper called "a Santa Claus double."

Dozens of visitors to Michigan recall seeing Meyer and his animals or having their pictures taken with him. He was his own attraction and Northern Michigan tourism bureau before the idea officially existed, even forming an early conservation club on his own.

Born in Ohio in 1870, he came to Shepherd with his parents, who were farmers, in 1876. Meyer was a lumberjack, coal miner, real estate salesman and erstwhile inventor of a "sugar beet lifter" and a logging tractor. Most of all, he was a showman with an active imagination and a facility for communing with four-hundred-pound bears and their cubs as well as deer and, reportedly, buffalo.

Spikehorn became famous, so much so that James A. Fitzpatrick, whose popular "TravelTalks" appeared in movie theaters for years, did a short film on Spikehorn and his bears along with footage on the Sleeping Bear Dunes and other Northern Michigan tourist attractions.

A sign in front of his bear den said: "Feed Conservation Officers to the Bear." Meyer's ongoing dispute with the law involved the fact that he had no license to keep and raise bears, deer and other animals—but he did it anyway.

One of Northern Michigan's most colorful and controversial characters for several decades was "Spikehorn" Meyer, here gamboling with inmates of his Bear and Deer Museum in Harrison. Meyer had a facility for publicity, especially about his clashes with state conservation officers. *Clarke Historical Library*.

Another court tussle was over a charge that one of his bears bit a visitor, something he vehemently denied. He alarmed court officials by stating he might bring several of his bears to court to "testify as material witnesses." Calling the court action "persecution," Spikehorn threatened to move his Bear and Deer Park to New York. Spikehorn was fined $50 but eventually made a settlement with the state. In 1949, he advanced the State

Conservation Department $30 for expenses of department witnesses at his trial on charges of keeping bears in captivity without a license. The *Detroit News* reported: "The case was settled and some of the witnesses were not required, so Spikehorn asked for a refund, with 54 cents interest." He got an $18 refund, but interest was refused.

Spikehorn "called game wardens and department officials a lot of names during the permit controversy," according to the news report, which added: "Spikehorn admitted he had at least 13 bears in his wild animal den along US-27 near Harrison, but he contends they are maintained for exhibition purposes and no permit is required."

One observer called Meyer a "favored local crank and bear wrangler" and "one of Northern Michigan's most colorful characters," although there is no evidence he ever "wrangled" the huge animals. His training method involved feeding them and fearlessly cavorting with them for the crowds—but treating them humanely.

Another report said Meyer exhibited his bears at an animal show in Petoskey and again clashed with officialdom. "The antics of the bears, he said, even held the spotlight while Gov. Kelly [Harry F., 1943–47] was making his address," reported the paper. "It was a good speech," Spikehorn acknowledged, "but the crowd has its eyes on my bears. So now they want to close me up."

In 1945, a *Detroit News* headline read, "Spikehorn Yields; Asks for Permit." He was in the process of appealing a $50 fine, imposed after he acted as his own attorney at a trial in Clare. As to his denial that a bear had mauled a visitor, Robert Furlong, a district conservation officer at Gladwin, retorted that Spikehorn could "save his money, because the facts are all in the files, and open for inspection."

He made even bigger news—also revealing he may have been pretty well heeled—in 1945 when he wrote to President Franklin Rooosevelt, British prime minister Clement Attlee and Russian dictator Joseph Stalin, offering $50,000 for anyone who would capture Germany's Nazi leader Adolf Hitler.

Spikehorn was legendary in another way, bragging about his membership in the Michigan Liars Club and regaling other members at annual meetings. In the style of fantasy Paul Bunyan tales, Spikehorn told of teaching blue jays at his ranch to spear pancakes he tossed into the air. The stunt went awry when troublesome children began tossing up iron stove lids, causing half the blue jays in the state to flutter away with bent beaks.

At age 67, he delivered several bear cubs and a young buck deer in a trailer with Florida license plates towed by a battered old sedan to a zoo in Ohio.

He gave an interview to the *Canton Repository* newspaper, claiming to be 84, and recounted some of his fantastic yarns. He brandished a blunderbuss musket for the press, claiming it was 319 years old and had come over on the *Mayflower*. There may have been some truth to the age of the gun, since the press reported the ancient firearm was stamped "Tower of London."

Meyer's political ambitions were scotched when he was charged with distributing defamatory literature about an opponent during a campaign for state legislature in the Clare-Isabella district in 1948. He was sentenced to thirty days in jail but was released after only three hours behind bars when election results came in and he had lost.

A man of many facets who was way ahead of his time, Meyer drew plans for a tunnel under the Detroit River for the Michigan Central Railroad; later, it was built after the same fashion he had suggested. He also suggested a tunnel across the Straits of Mackinac, a crossing later fulfilled by the Mackinac Bridge, which opened in 1958. Those futuristic visions were picked up by the press and gave him even more publicity for his animal exhibit.

Spikehorn died at age eighty-nine on September 19, 1959, in a nursing home in Gladwin and was buried in the Salt River Cemetery in Shepherd. His tombstone, as befitting his lifestyle, grandiosely reads: "Central Michigan Naturalist."

SOO LOCKS

TRANSITING IRON ORE FROM U.P., CANAL CREATES U.S. SUPERPOWER

The locks tipped the balance to the North in the Civil War by allowing ships carrying iron ore to reach mills and foundries and cast more cannon and guns for the Union army.

When an old Chippewa graveyard was moved to make way for them, several thousand natives living nearby began pounding *wabeno* war drums and had to be calmed so work could continue.

Twenty-four-year-old Charles T. Harvey was in charge of the work and had to import four hundred men from Detroit because the local whites, natives and French-Canadian voyageurs "despised" the project and would not work on it.

The project, first called the St. Marys Falls Ship Canal, was a monumental triumph of man over nature, stamping its mark on Northern Michigan and midwestern industry forever. It was completed in twenty-two months from 1853 to 1855. Harvey's company spent $999,802 on the project and received government compensation of 750,000 acres of land, including iron, copper and timber lands.

"They are legendary in the maritime world—a group of mighty Locks that have provided safe passage and a vital shipping connection within the Great Lakes for nearly 160 years," enthused one historian about the locks at Sault Ste. Marie, commonly referred to as the "Soo Locks."

The St. Marys River, connecting Lakes Superior and Huron, was historically unnavigable because of a twenty-one-foot drop at Sault Ste. Marie. "While a brave person in a canoe or other small boat could 'shoot the

The Soo Locks at the St. Mary's River have been continually expanded to accommodate ever-increasing volumes of ship traffic. During World War II, 90 percent of the nation's iron ore was funneled through the Soo Locks. *Clarke Historical Library*.

rapids' going downstream, no ship of any size could do so without foundering on the many rocks in the rapids," explained a display at the Clarke Historical Library, Mount Pleasant. "Further downstream, narrow passages, rocks and occasionally low water levels often made it impossible for a large vessel to reach Sault Ste. Marie."

The locks, opened in 1855, provided a passage for the iron ore from Upper Peninsula mines to steel mills in the nation's heartland. The locks thus enabled the United States to surpass Great Britain, traditionally the world's leading producer of iron and steel, and paved the way to superpower status for America.

Local tourism promoters expansively boast:

> *But they are so much more. They are a wonder of engineering and a living, breathing history lesson. They provide a flight of fantasy as one imagines the highs and lows of a life spent on the seas. They are the destination for nearly 1 million visitors annually—each taking something different and fresh away from the experience. How can something so old feel so new? Visit and see for yourself!*
>
> *Whether tracing the path of a 1,000-foot freighter aboard a tour boat or watching the action from the observation platform located within Soo Locks park, first-timers and old-timers alike flock to the Soo Locks to see vessels haul vital cargo and share a wave and a smile with the merchant mariners aboard these massive ships.*
>
> *Until the first State Lock was built in 1855, explorers, fur traders, and Native Americans portaged their canoes and cargoes around the rapids. Everything would change when a 21-foot drop in water levels was rendered*

less important with the construction of a Lock. Much has been written about the history of this impressive facility.

The locks are vital to national security and are seldom shut down completely. However, during World War II, they were virtually closed, and the U.S. Army deployed over ten thousand troops to guard the Soo area night and day. Vessels jammed with supplies vital to the war effort—wheat, iron and copper—streamed through the "Miracle Mile" bow to stern. Tethered barrage balloons—designed to deny low-level air space to enemy planes—filled the skies over Sault Ste. Marie. Only essential shipping was permitted through the locks.

During its first year of operation, the canal was navigated by just twenty-seven vessels. In recent years, nearly seven thousand vessels pass through the locks annually, hauling 86 million tons of cargo. The four locks operated by the U.S. Army Corps of Engineers—the Davis, Sabin, MacArthur and Poe—continue to provide the much-needed connection between Superior and Huron. Currently, all ships utilize the larger Poe (1,200 feet) and MacArthur (800 feet) locks.

The *Detroit Free Press*, noting the 150th anniversary of the locks, commented:

> *Ships powered first by sail and later by steam and diesel have traveled through the locks. Now, the queens of the Great Lakes are the gargantuan 1,000-footers that tower six to eight stories above the locks, ships so long that if their bows touched the bottom of the lake in most spots, their sterns would stick up hundreds of feet into the air. The ships are so large, their sides often get scraped as they squeeze out of the locks.*

Steve Welch, co-chair of the 150th anniversary celebration, noted, "They only have 2 1/2 feet on each side when they go in and out. It's like a hand-and-glove sort of thing. They'll rub against the sides somewhat when they go out."

The Soo Locks Visitors Center is open from mid-May through mid-October from 9:00 a.m. to 9:00 p.m.

NATIVES FROM NORTHERN MICHIGAN BROUGHT HUNTING SKILLS, BRAVERY TO THE CIVIL WAR

Although Native Americans were banned from serving in the Union army during the Civil War at first, after heavy losses in the Battle of Gettysburg, July 1–3, 1863, Indians were allowed to enlist. By contrast, the South had up to twenty thousand natives in gray uniforms from the beginning of the war.

Many Michigan Indians were still upset about losing land through violations of treaty agreements and refused to fight in a war they didn't consider their own, according to Eric Hemenway of the Little Traverse Bay Band of Odawa Indians. In fact, Michigan Indians had fought the United States on the side of the British in the War of 1812.

About one-fifth, more than 30 of 155 members of Company K of the First Michigan Sharpshooters, hailed from Northern Michigan. And most of those soldiers were members of the Three Fires Tribes, the Ojibwe, Odawa or Pottawatomi. Cultural and language barriers prevented the Indians from mingling freely with other troops. "They were Union soldiers, but at the same time they were their own group and were treated as the Indian company," Hemenway told a Mackinaw City Historical Society group several years ago.

The Indians wielding muskets had to hit a twenty-inch target one hundred yards away five times in a row to qualify for the Sharpshooters. They were skilled at surprising Confederate troops in trenches, using camouflage and stealth skills they had practiced as hunters in the woods.

At the Battle of the Crater during the long siege of Petersburg in 1864, a group of blacks and Indians was sent into the crater in an attempt to breach the Rebel line, Hemenway recounted. "Noticing that many of their comrades were mortally wounded, several Indians in the crater raised their shirts over their heads and sang a traditional death chant as a preparation for dying."

Antoine Scott, listed on the Company K roster as a seventh corporal from Pentwater in Oceana County, is said to have repeatedly crawled up the side of the crater to fire at the Rebels in defense of those Indians who were chanting. "Union soldiers were amazed by his courage to protect his buddies," said Hemenway, noting that Scott was nominated twice for medals for bravery.

A book by Raymond J. Herek, former instructor at Alpena Community College, *These Men Have Seen Hard Service: A History of the First Michigan Sharpshooters*, is described by the publisher, Wayne State University Press, as "a compelling political, social, ethnic, and military drama, examining the lives of the 1,300 men of the First Michigan Sharpshooters for the first time, beginning with the regiment's inception and extending through postwar activities until the death of the last rifleman in 1946."

The company was mustered into service in Kalamazoo and sent to Chicago to guard Confederate prisoners. It took part in the Wilderness campaign and the operations leading to the fall of Richmond. The *Charlevoix County Herald* took note:

> *Company K fought heroically and suffered an unusual number of fatalities and practically every member at one time or another was wounded. Less than half the company returned and those who witnessed the return of the survivors recalled that as they passed through the village of Little Traverse every one was limping or bore other evidences of wounds received.*

The highest-ranking Indian in Company K was Second Lieutenant Garrett A. Graveraet of Little Traverse, Emmet County. "He was fluent in English, French and American Indian dialects, and was a musician and artist with good warrior skills," wrote Herek. He was teacher at the government school at Cross Village. Graveraet recruited many of the Native American soldiers, including his own father, Henry Graveraet Jr., forty-seven. After his father was killed on May 12, 1864, at the Battle of Spotsylvania Courthouse, "he very carefully marked the grave and the surrounding trees so that he could find it afterwards, telling me he expected to return and take up the

body and bury it in Michigan," wrote Major Edward J. Buckabee, the regiment's adjutant, in his memoirs.

An artillery shell shattered young Graveraet's arm on June 17 at Petersburg. The arm was amputated, and he died of complications in a Washington, D.C. hospital. He was twenty-three years old.

Both Graveraets were buried in St. Anne's Catholic Mission Cemetery on Mackinac Island.

PURPLE GANG VIOLENCE, PROHIBITION–ERA CRIME SHAKES QUIET CLARE AND LUPTON

Michigan jumped the gun on Prohibition, the legislature passing the Damon Act in 1917, giving gangsters a head start on illegal liquor sales that led to crimes of all sorts. Detroit hoods were quick to profit, hauling hooch by boat from nearby Canada. They soon moved out into other, smaller cities when things got too hot.

Out-of-the-way farm and resort communities like Clare and Lupton, Michigan, were havens for gangsters in the 1920s and 1930s; the tales of mayhem that accompanied them to the hinterlands continue to resonate. By the late 1920s, the federal government was spending more than a quarter of its enforcement budget just trying to corral the Purples and other rum-running gangs in Michigan.

Sponsored by state senator John A. Damon of Gratiot, Isabella and Mecosta Counties, the "bone dry" law of 1917 prohibited bringing intoxicating liquors into the state.

Driven by a strong temperance movement, half of Michigan, forty counties of eighty-three, had already gone dry by 1911. Liquor distilleries Hiram Walker and J.P. Wiser had moved to Canada in the 1880s, as Carrie Nation was running amok with her hatchet, promoting the banning of alcoholic drinks by leading temperance raiders in wrecking saloons.

Although the Damon Act was declared unconstitutional by the Michigan Supreme Court, the ball was rolling, and the teetotalers rejoiced when Prohibition was put in place by a constitutional amendment and took effect in 1920.

The Purple Gang was a mainly Jewish mob, so called because its activities were "off color," or "purple." Besides bootlegging, illegal drugs and gambling, Michigan was plagued with prostitution, especially in Detroit, where hundreds of houses of ill repute operated. The Michigan State Constabulary was kept busy trying to stem the flow of liquor across the Ambassador Bridge and through the Windsor Tunnel from Canada, in addition to the booze boats speeding across the Detroit and St. Clair Rivers and dumping their alcoholic loads, many from Walkerville, Ontario, with cohorts on the shore.

The gangsters brought big-city glitter and crime and corruption to disrupt the placid lives of the small-town burghers and sheriffs, who were used to dealing mainly with law-abiding fellow bumpkins.

Clare was known as the "Gateway to the North," from which motorists fanned out to the Traverse City/Petoskey/Harbor Springs area, to Mackinaw City and Mackinac Island, to Rogers City/Alpena and the Thunder Bay area. In the fall, deer hunters flooded in to participate in the annual ritual, and in the spring, fly fishermen were drawn to such pristine streams as the Boardman, AuSable, Manistee, Jordan, Platte, Sturgeon and others.

Clare received additional focus by Michigan's oil boom centering in the central and northern part of the state, which attracted Texas promoters like Jack Livingston and his cousin, Purple Gang attorney Isaiah Leebove, of New York, whose cronies included gang boss Meyer Lansky and others of his ilk. Livingston and Leebove were to carry their feud over oil land to the posh Doherty Hotel in Clare. The Doherty was a popular stopping off point for travelers from the South to Northern Michigan, one of the few hostelries where the amenities of big cities like Detroit and Chicago could be enjoyed among one's peers. Unfortunately, too much of the big-city atmosphere was imported into tiny Clare, a thriving mid-Michigan market town that was about to enter the annals of crime along with other out-of-the-way towns in vacation spots.

The infamous Bonnie and Clyde had already sent gang members to case a bank in Midland, where the $75,000 biweekly Dow Chemical payroll became a magnet for criminals, leading to a botched bank robbery and a shootout on Main Street in 1937 and the last execution in Michigan history. Gunman Anthony Chebatoris, the Hamtramck bandit, was hanged in July 1938 for the federal crime of murder in commission of a bank robbery. "Public Enemy No. 1" Pretty Boy Floyd had been chased out of Bay City State Park that same year, en route to his death at the hands of the law in Ohio. Floyd and Billy "The Killer" Miller kidnapped

Mid-Michigan oil baron Jack Livingston puffed big cigars and dressed like the larger-than-life Texas character he was. *Norm Lyon Collection, Clarke Historical Library.*

a Pinconning gasoline station attendant in 1931 before being tracked down by legendary FBI agent Melvin Purvis.

Now it was Clare and Lupton and smaller towns in between that were to taste the flavors of crime in more redolent aspects than ever experienced. The 1920s and 1930s were the lawless years, fueled by Prohibition; these were the days when criminals had faster cars and bigger guns than the

police. These were the days when remote places like Clare would be vaulted into the headlines of newspapers big and small by crimes never before seen in such places.

"As the conflict escalated, Livingston became obsessed with the idea that Leebove had put out a contract on his life with his gangland pals, Jewish mobsters Meyer Lansky and Arnold 'The Brain' Rothstein," commented the local newspaper.

It was at the Grill Room of the Doherty at 10:15 p.m. on Saturday night, May 16, 1938, that a demented Livingston fired the shots that killed Leebove and wounded another gang mouthpiece, Byron "Pete" Geller. After the shooting, Livingston timidly turned over the pistol to assistant hotel manager Harry Wehrly. Livingston was seething over Leebove's refusal to sell him forty-five potentially oil-rich acres for his Mammoth Producing and Refining Company, the largest independent oil firm east of the Mississippi River at the time. About Geller's wounding with two shots to the left thigh and leg, Livingston "stated that he was sorry, that he considered Geller his friend and would not harm him for the world."

"Jack! Jack! Why?" Leebove reportedly exclaimed after three shots from Livingston's pistol rang out, one piercing Leebove's chest—going through his heart—another through his left forearm and right hand and the third hitting Geller in the leg. "Mr. Leebove fell from his seat to the floor and died instantly," the local newspaper reported.

The local weekly newspaper, the *Clare Sentinel*, got out its largest all-capitals wood type to splash a seven-column banner "ISIAH [*sic*] LEEBOVE SHOT AND KILLED HERE SATURDAY EVENING," among more mundane stories of local Masonic degrees being conferred, high school seniors enthused over a trip to the Holland (Michigan) Tulip Festival, the glee club's spring concert and the second staging of a high school play called *Craig's Wife*.

Another smaller headline was a tip-off about the legal follow-up: "Insanity Defense Probable in Jack Livingston Trial." That was, in fact, the defense. Livingston had hallucinations and delusions that Leebove and gangsters were after him and that Leebove had swindled him out of some oil leases. It was averred that he drank a quart of liquor a day, passing from the stage of chronic alcoholism to alcoholic insanity. The slayer was declared insane by a circuit court of nine men and a woman after a three-week trial and nine hours of deliberation in Harrison, the Clare County seat, on December 15, 1938. Judge Ray Hart ordered him confined to the Traverse City Asylum for the mentally ill.

Leebove's body was taken to Pittsburgh, his hometown, for burial. Livingston was released from the asylum after a few years. At age fifty-five, he died of a drug overdose in New Jersey.

Stories of the Purple Gang at Lupton are more difficult to trace, and some may be apocryphal. Most of the lurid tales are linked to Mike Gelfand, a.k.a. "One-Armed Mike," the original owner of the Graceland Ballroom and adjoining Wigwam. Gelfand allegedly had ties to the Purples, who may have hidden out in Lupton under his sponsorship. Locals recall roller skating at the Graceland back in the day. Built in 1933, the Graceland was sold by Gelfand in 1938.

Tales of the Graceland were hyped by one of its last owners, Floyd Pastula, who placed dummies of gangsters with machine guns in the balcony of the ballroom. I interviewed Pastula for the *Bay City Times* in the 1970s and saw the hokey gangster models in the iconic log building.

Male strippers were featured in some of the last shows held at the Graceland, productions attended by delighted ladies from Ogemaw and Iosco Counties, according to some reports. The Graceland burned down on December 29, 1981, under what local volunteer firefighters called "mysterious circumstances." Pastula, who lived next door, heard the flames roaring through the pine log structure but was helpless to save it.

Graceland Ballroom at Lupton was a longtime lure for tourists and allegedly for gangland figures from downstate, exploited by an owner who put gangster dummies with machine guns in a balcony. It burned mysteriously in 1981. *Courtesy of MyBayCity.com.*

Supposedly, Purple Gang members also hung out at a place called "South Branch Ranch," on the South Branch of the AuSable River. Some local residents say they can identify the cabins on AuSable Lake allegedly owned by gangsters back in the 1930s. The ranch had a dance hall, a large swimming pool and an indoor riding arena as well as hunting lands, servants' quarters, guesthouses and other gangland amenities like hidden tunnels and secret rooms, according to local author Alan Landrett. The ranch was seized by the IRS for non-payment of back taxes in the late 1970s and later torn down to clear space for a golf course.

HUGE CROSS IN THE WOODS SCULPTURE A FOCAL POINT FOR VISITORS TO NORTHERN MICHIGAN

Y ou may have seen his art deco statues, fountains and monuments but not realize who it was that created the sculptures, for instance, in metropolitan settings: the *Spirit of Detroit*, at the foot of Woodward Avenue; the Cleveland War Memorial: *Peace Arising from the Flames of War*, on the mall in downtown Cleveland, Ohio; *Freedom of the Human Spirit* in New York City at the National Tennis Center; and *Man and the Expanding Universe* fountain in the South Court of the U.S. Department of State in Washington, D.C.

But unless you have seen the *Christ on the Cross*—or the *Cross in the Woods*, as it is often called—at the Indian River Catholic Shrine in Indian River, you may not grasp the expansiveness of the mind and inspirational art of Marshall Fredericks.

The twenty-eight-foot bronze Corpus weighs fourteen thousand pounds and is mounted on a fifty-five-foot-high redwood cross. It was believed to be the largest crucifix in the world when it was erected in 1959. Fredericks chose not to depict the pain and suffering of Jesus from the crown of thorns and wound in his side, instead "he shows the powerful body of Jesus at peace in the moment after death."

To be sure, this iconic display in the woods is not ignored by the public because of its remoteness; it is viewed by an estimated 300,000 visitors a year.

Because local Catholics had to travel long distances, Bishop Francis J. Hass started the process of acquiring land for a new church at Indian River in 1946 and was given the property in 1948 for one dollar and a box of

Three curious children intently watch the installation of the bronze Corpus on Marshall Fredericks's *Cross in the Woods* sculpture at Indian River in 1959. *Marshall M. Fredericks Sculpture Museum.*

candy. A church on the site was designed by Alden B. Dow, noted Midland architect and student of Frank Lloyd Wright, to resemble a longhouse, one style of Native American residence.

In 1952, the idea arose to erect a huge crucifix to attract more visitors to the church and the shrine and museum that had been built there.

Church officials stated, "The process of creating the Christ figure for the cross took four years and is one of the largest castings to ever be shipped across the Atlantic Ocean. The figure is attached to the cross by 13 bolts that are 30 inches long and two inches wide."

The site was declared a national shrine by the U.S. Conference of Catholic Bishops in 2006.

Marshall Fredericks was born in Rock Island, Illinois, in 1908. He grew up in Cleveland and graduated from the Cleveland School of Art in 1930. He studied in several countries in Europe and earned a fellowship to study with noted sculptor Carl Milles in Sweden. In 1932, when Milles was directing art programs at the Cranbrook Academy of Art and Kingswood School in Bloomfield Hills, he invited Fredericks to join the staff there.

From 1942 to 1945, Fredericks served in the U.S. Air Force as a lieutenant colonel. He and his wife, Rosalind Cooke, had five children. He died in 1998 at age ninety in Birmingham, Michigan.

The Marshall Fredericks Sculpture Museum has been established at Saginaw Valley State University, where many models of his castings are housed. The plaster model of the Indian River corpus had been in storage for two decades at the foundry in Scandinavia and took seven years to restore before placed at the museum.

INDEX

ABOUT THE AUTHOR

After graduation from Michigan State University School of Journalism and stints in smoky newsrooms in crowded big cities like Chicago and Detroit, covering Northern Michigan was a welcome escape, but one not without excitement. As a reporter for the *Bay City Times* in the 1960s and 1970s, Dave Rogers covered ship sinkings, gas well fires, quarry dynamiting in Alpena, old Purple Gang hangouts, Wurtsmith Air Force Base, abandoned iconic Mackinac Island structures (at the time) like Stonecliff and Mission Point—all were in his purview. Who can forget the Stone-Skipping and Unicorn Hunting events cooked up by island and Lake Superior State University promoter Bill Rabe? How about Rabe's ritual of taking the pool table out of the Mustang Bar in the spring, with newsmen holding crossed pool cues overhead, to make way for the summer tourist influx? AP conferences at Hidden Valley in Gaylord, interviewing Governor G. Mennen Williams on a plane from Lansing to Mackinac, all were imprinted on his mind and added to the Northern Michigan he knows. Writing the folklore history of the Paul Bunyan legend took him to Oscoda and places like the Pack House Inn, Shoppenagon's Hotel in Grayling, the Holland Hotel in East Tawas and Spikes Keg 'O Nails in Grayling. More than a half century in journalism has given this writer a perspective on the Northern Michigan region that is reflected in this book. I hope that the woodsy flavor appeals to your reading appetite.

Visit us at
www.historypress.com